Natural Yarn Dyes

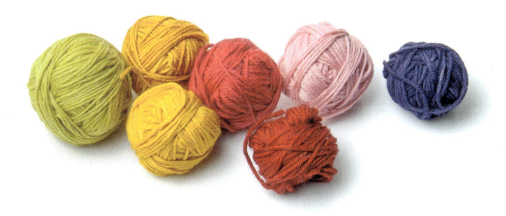

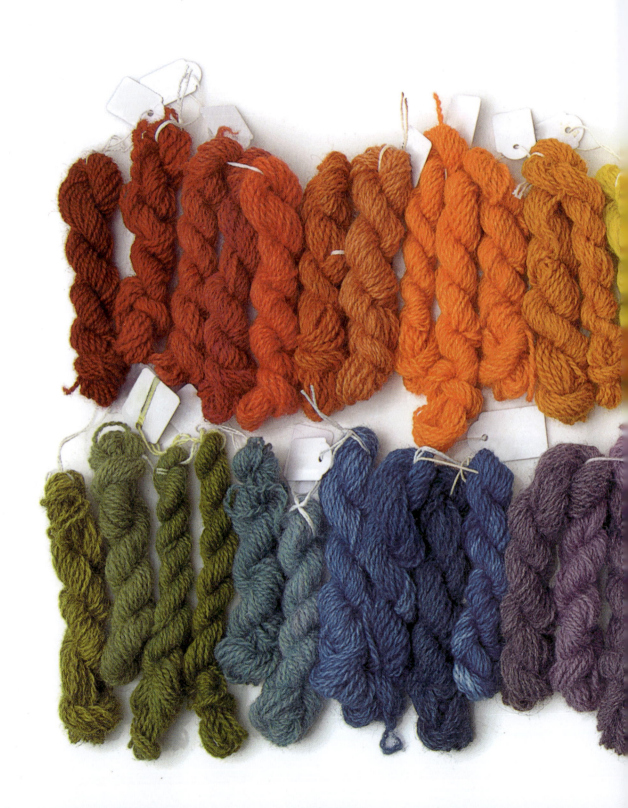

Natural Yarn Dyes

25 vibrant & sustainable recipes

Anna Bauer &
Eva Zethraeus

Search Press

First published in the UK in 2025
by Search Press Limited
Wellwood, North Farm Road,
Tunbridge Wells, Kent TN2 3DR

Färga garn och sticka
Copyright © Anna Bauer & Eva Zethraeus
and Bokförlaget Polaris, 2021.
English edition published in agreement with
Politiken Literary Agency and Bennet Agency

English translation by Burravoe Translation Services

Editors: Sophia Lundquist and Julie Brooke
Graphic design: Annika Lyth
Photos: Thomas Harrysson (pages 8, 11, 12, 24, 26 and 27)
Other photos: Anna Bauer and Eva Zethraeus
Other illustrations: see list on page 93
Cover photos: Anna Bauer and Eva Zethraeus

ISBN: 978-1-80092-268-6
ebook ISBN: 978-1-80093-267-8

All rights reserved. No part of this book, text, photographs or illustrations may be reproduced or transmitted in any form or by any means by print, photoprint, microfilm, microfiche, photocopier, video, internet or in any way known or as yet unknown, or stored in a retrieval system, or used as part of a dataset for the purposes of machine learning, without written permission obtained beforehand from Search Press. Printed in China.

The Publishers and author can accept no responsibility for any consequences arising from the information, advice or instructions given in this publication.

Readers are permitted to reproduce any of the projects in this book for their personal use, or for the purpose of selling for charity, free of charge and without the prior permission of the Publishers. Any use of the projects or images thereof for commercial purposes, or machine learning purposes, is not permitted without the prior permission of the Publishers.

Disclaimer
The volume measurements in this book are based on UK measures using metric measurements, and the imperial equivalents provided have been calculated following standard conversion practices. If you need more exact measurements, there are a number of excellent online converters that you can use. Always use either metric or imperial measurements, not a combination of both.

Suppliers
If you have difficulty in obtaining any of the materials and equipment mentioned in this book, then please visit the Search Press website for details of suppliers:
www.searchpress.com

Bookmarked Hub
Two knitting patterns based on the processes demonstrated in this book are available to download free from the Bookmarked Hub: www.bookmarkedhub.com
Search for this book by title or ISBN: the files can be found under 'Book Extras'. Membership of the Bookmarked online community is free.

You are invited to visit Anna's website at: www.annabauer.se
Follow Anna on Instagram: @annabauergbg
Follow Eva on Instagram: @ezeth

Opposite: raw wool can be dyed in a net bag.
Handle the wool gently in the bath to avoid felting.

Contents

The hunt for sustainable colours 8

BEFORE YOU BEGIN 12

Myths about dyeing with plants 14
Picking and collecting 14
Environment and safety 15
Working with yarn 15
Washing fastness 16
Lightfastness 16
Equipment 17
Parameters affecting colour 17
The dyeing process 19
Things to bear in mind for
 successful dyeing 20
Preparations 21
Mordanting 21
Natural mordants 23

DYE RECIPES 24

Natural dyes 27
Mordant dyeing 27
Vat dyeing 27

Dyeing with plants 28

Madder 30
Beetroot 34
Plum 36
Yellow onion 38
Birch 40
Red onion 42
Tansy 44
Golden marguerite 46
Goldenrod 48
Rhubarb 50
Heather 52
Dyer's weed 54
Eucalyptus 56
Common reed 58
Brazilwood 60
Logwood 62
Red cabbage 64
Walnut 66
Indigo 68

Dyeing with fungi 72
 Surprise webcap mushroom 74
 Velvet roll rim mushroom 76
 Scaly tooth fungus 78
 Sulphur tuft 80

Dyeing with lichens 82
 Rock tripe 84
 Crottle 86

Next steps 88
 Using the same dyebath more than once and overdyeing 88
 Afterbaths 88
 Care 89

Glossary 90

References 92
 Further reading 92
 List of illustrations 93

Our thanks to 96

The hunt for sustainable colours

Our ambition for this book was to create an inspiring, user-friendly handbook on dyeing with natural colourants. The title 'plant dyes' may be a bit misleading as, strictly speaking, it is also about fungi and lichens, which are not part of the vegetable kingdom.

As keen knitters we have focused mainly on dyeing woollen yarns. Another of our ambitions was to select the colourants and methods that produce dyes that are as lightfast possible.

With historical sources as our starting point, we have experimented and progressed by trial and error, rejecting some recipes and continuing to use and develop others. We have made quite a few discoveries of our own, cheered and groaned with disappointment over the dye pans, learned the scientific names of fungi and the effect of the pH value on colour.

There are many excellent older books on dyeing that are sadly impractical to use today, because the recipes often contain poisonous chemicals which we want to avoid for environmental and health reasons. For example, we have chosen not to use tin crystals, lead acetate (sugar of lead), potassium chromate, sodium hydrosulphide, hydrochloric acid, sulphuric acid or arsenic.

Our aim was to create recipes for lightfast dyes and, as far as possible, to replace or exclude the most toxic and environmentally hazardous chemicals. This is not to say that all the substances we have included are completely innocuous. For example, ammonia is strongly alkaline and you should avoid breathing in the fumes. Always wear gloves and ensure good ventilation when using it.

Dyeing textiles with natural pigments has a very long history, and it was not until the mid-19th century that natural dyes encountered competition from synthetic pigments. Since then the popularity of botanical dyeing has gone in waves. The use of traditional plant dyes increased during the 1970s, and since the 2010s a more experimental attitude with ecological characteristics has become popular.

It is always fun to experiment, but sadly not all plants and methods produce lightfast dyes with staying power. This may not matter if you enjoy playing with colour or the dye is for a piece of clothing that can easily be dipped in another dyebath when it has faded. But when you spend time and effort knitting a garment you do not want the colour to fade after a short time.

Botanical dyeing is a multi-dimensional experience involving colour, chemistry, craft skills and nature. It can begin in the countryside. Going outdoors and picking flowers on a warm summer evening or gathering mushrooms on a golden autumn day gives you a reverence for nature. Show respect when you collect plants, mushrooms and lichens and, if you live in the United Kingdom, remember the Countryside Code.

You can find most of the dye plants in the wild and you will probably have others in your kitchen: save your onion skins and the eucalyptus from your weekend bunch of flowers, plus make use of the red cabbage and beetroot that are beginning to wilt in the fridge. Or grow your own dye plants. With some pigments, such as cochineal and indigo, the easiest thing is to buy them.

There is something special about the processes around botanical dyeing: waiting as patiently as you can for the temperature in the dyebath to rise or fall (allowing things to take their time is probably the most difficult part); fishing out the lukewarm yarn and rinsing it so you can finally see the result; and last but not least, knitting with your plant-dyed yarn.

Anna Bauer & Eva Zethraeus
Konstepidemin, Gothenburg

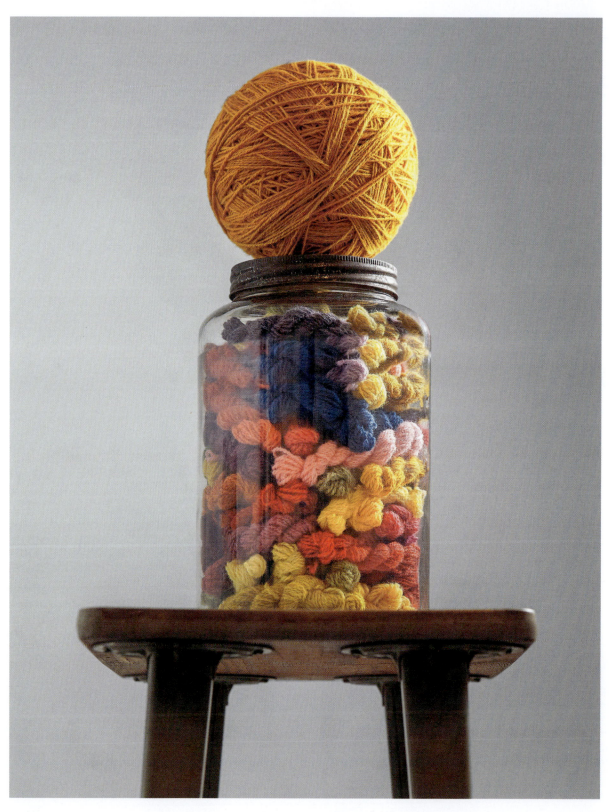

Before you begin

Dyeing with plants involves a number of stages, and while the preparatory work is not particularly difficult, it all takes time. Be as patient as you can, put some coffee on and read through the whole of this section about preparations before you begin.

Myths about dyeing with plants

There are a lot of prejudices and preconceived ideas about dyeing with plants that we need to address before we begin. Below are a few myths we have come across and which we would like to dispel, or at least clarify.

It usually results in different shades of dirty yellow
Absolutely not. It is true that many plants produce shades of yellow, but the drab tones that many people associate with plant dyeing probably have a lot to do with the fact that those shades were fashionable in the 1970s, when botanical dyeing was last in vogue. Also, they often used different kinds of afterbath with copper sulphate and iron (ferrous) sulphate to make the dyes more lightfast, which also made the colours dimmer. Read a bit further on and you will see some great colours.

Dyeing with plants makes the yarn scratchy
Yes and no. Many people have undoubtedly experienced scratchy sweaters from plant-dyed wool, but the yarn was probably already scratchy to begin with. However, if you 'shock' the yarn with sudden changes in temperature or the dyebath is too hot, it may in some cases become rough and feel scratchy.

The colours fade
Yes and no. Some colourants are better than others. We have tried to select those that are the most lightfast and we explain this later in the book. It is hard to get away from the fact that some colours change a little over time. Be sure to store your yarn and your knitted garments away from direct sunlight.

You always use a lot of urine with botanical dyeing
Hmm... there are certainly old recipes that use urine; a well-known example is Cajsa Warg's recipe for 'pot blue'. We have heard many sorry stories about urine and dyeing with plants, so people have evidently encountered it recently. In the past, urine was fermented to reduce the oxygen in the dyebath. We prefer to use ammonia.

Picking and collecting

In some parts of Europe there is a right to roam and to pick flowers, fruits and fungi anywhere that is not considered private property or a protected area. In the United Kingdom, the Countryside Code lays down rules for behaviour aimed at protecting the environment and respecting those who live and work in the countryside. Plants are not to be uprooted, but it is possible to gather parts of plants for dyeing, as well as fruits and fungi. There is no right to roam in the United States, but in such a large country there are opportunities to gather plants in the wild. Before going out to collect plants for dyeing, you should check for any local regulations.

Be aware that mosses and lichens generally grow slowly, so you should be extra careful when you collect them. We only collect lichens that have come away from stones or branches after rain.

Wherever you are, common sense should prevail, and you should abide by the basic rule: Do not disturb, do not destroy.

Environment and safety

- Respect the Countryside Code when you collect dye-making items from the countryside. Remember that plants may be protected in various parts of the country. Find out what applies where you live.

- Do not store poisonous colourants (for example dried fungi) near food or where children and pets can get to them.

- Wear a mask and gloves when necessary and ensure good ventilation.

- Copper sulphate is toxic, but you can empty out the small amounts remaining in the mordant bath after use when you are dyeing on a small scale. If you are uncertain, contact your local authority or a recycling centre to find out what applies where you live.

- Neutralize or dilute acid or alkaline baths before emptying them out.

Working with yarn

Most of the recipes in this book have been adapted for wool and other animal fibres.

In the same way that bleached hair absorbs more dye than untreated hair, bleached yarn absorbs more dye than unbleached. If you want bright colours, our tip is to work with a bleached yarn.

A natural grey woollen yarn gets a fine, mixed, 'lively' look when it is dyed. By dyeing bleached, unbleached and grey yarns in various shades you can easily get many subtle variations from the same dyebath. Grey yarn often turns green in a yellow bath.

Superwash wool is treated with chemicals, for example to make it machine washable. This treatment means that many of the wool's natural properties disappear, but whatever you may think about superwash, it absorbs dye very well.

Sock yarn with a certain proportion of polyamide and nylon is also excellent for dyeing.

Silk yarn which, like wool, is made from an animal fibre, absorbs dye in much the same way as woollen yarn.

Washed, unspun wool can be dyed in a net bag.

Cotton, linen and hemp, which are cellulose fibres, can also be dyed but they absorb the dye in quite a different way. Some colourants, for example indigo, adhere equally well to cotton, while others become much lighter.

As a rule, when dyeing it is easier to get an even colour on yarn than on fabric. If you dye entire garments, remember that irrespective of what material they are made from, they will very often have been sewn with a synthetic thread that will not absorb the dye.

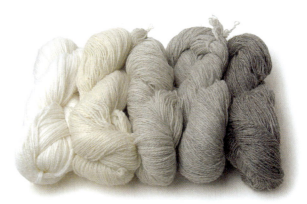

The natural colour range of wool: bleached, natural white and various shades of grey.

Washing fastness

How well a dye stands up to washing is not quite the same thing as lightfastness. As a rule, plant dyes used on wool retain their colour well, but because woollen garments are not generally washed frequently, we have not placed much emphasis on that.

Lightfastness

Lightfastness – how quickly a colour fades – varies from one dye to another. As a rule, lighter colours are less lightfast than darker ones, but the dyeing method also has an effect. A concentrated dyebath (containing a lot of colourant) results in better lightfastness than a weaker dyebath; generally a longer time in the dyebath also produces a longer-lasting result. Afterbaths containing, say, copper or iron can also enhance the lightfastness of a dye.

The colourants with the best lightfastness are madder, indigo and dyer's weed. For obvious reasons we have rejected the dyes with the lowest/worst lightfastness. Some colours darken first and then fade.

How to do a lightfastness test

Wind the yarn round a piece of card. Write on it the dye you used, the mordant, any afterbath and the date. Place the card in a window and cover half of it. In this way you can easily compare the two halves to see how light affects the colour over time.

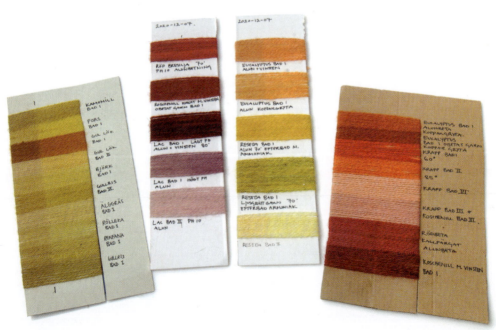

Some examples of lightfastness tests. The dyer has included the plant source and bath number. Notice the effect of sunlight on the leftmost sample.

Lightfastness scale for the dyes in this book

We created this scale after studying colour tests that had been in a north-facing window for six to eight months.

1 Poor
2 Mediocre
3 Moderate
4 Good
5 Excellent
6 Exceptional

Equipment

You will need quite a lot of equipment for dyeing. Some of the things you will certainly already have in your kitchen or your broom cupboard, but we recommend that the pans/casserole dishes and all the other equipment you use for dyeing are *not* used for cooking purposes. You can often buy suitable pans second-hand: the bigger the better!

You will need

- Large pans, at least 12 litres (2¾ gallons)
- Measuring jug
- Buckets
- Sticks for stirring and lifting out the yarn (for example, a dowel rod from a DIY store)
- Wooden or metal ladles and spoons
- Digital scales that can weigh from 5g (³⁄₁₆oz) up to several kilograms
- Cotton string
- Scissors
- Somewhere to hang the yarn up to dry – protect the floor if necessary
- Strainer or colander for straining off pieces of plant matter
- Rubber gloves and a face mask
- Glass containers with lids (for indigo and lichens)
- Hob or stove
- Thermometer, for example a digital meat thermometer
- Digital pH meter or litmus paper
- Buttons and paper labels for marking the yarn

Parameters affecting colour

Botanical dyeing is a bit like magic, but also something of a lottery. Both the plants (or the fungi or lichens) and the wool are materials obtained from living organisms. There are many factors that may affect the final result, for example where and at what point in the season you picked the plants (for instance, birch picked in spring produces different shades from that picked in late summer), whether the plant is fresh or dried, the temperature of the dyebath, the quality of the water, the pH of the dyebath, whether the yarn you are dyeing is bleached, natural white or grey, the material the pan is made from, how the yarn is mordanted, etc. So it is difficult to reproduce a precise hue for a second time, and virtually impossible to give recipes for exact shades of colour. Think of the recipes in the book as a starting point for your own experiments with natural dyes.

It is always good to make notes while you are working so you can remember what you did and how you did it.

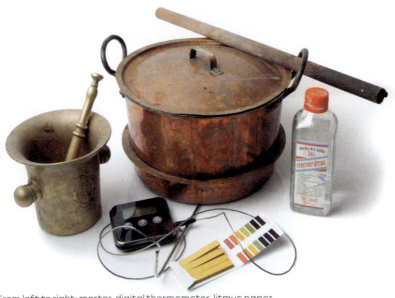

From left to right: mortar, digital thermometer, litmus paper, large copper pan with sticks for stirring, and white vinegar.

Pots and pans

Stainless steel or enamel pans are the best for botanical dyeing. Iron and copper pans affect the outcome of the dyeing, which can be useful in some cases. Copper pans give deeper tones of yellow and green, iron pans give darker, murkier tones that are closer to brown. Copper and iron increase lightfastness.

Aluminium pans are not good for botanical dyeing; using aluminium seems to result in colours that are not fast.

The bigger the pan the better, because it is easier to get an even dye and keep an even temperature in a larger pan.

Reminder: never use the same pans for dyeing and cooking.

pH values

The pH scale indicates the acidity or alkalinity of liquids by measuring the concentration of hydrogen and hydroxide ions. The more hydrogen ions there are, the lower the pH. The pH scale goes from 0 to 14, where 0 is the most acidic and 14 the most alkaline.

The pH can be measured with a digital pH thermometer or using litmus paper. Solutions with a low pH value are acidic, while those with a high pH value are alkaline, and solutions with a pH of 7 (the pH of pure water at 25°C/77°F) are called neutral.

In botanical dyeing, the pH can have a considerable effect on the colour, and you can make use of this to get a greater variety of subtle shades from the same plant. White vinegar, wine vinegar and citric acid can be used to make a dyebath acidic, while ammonia, bicarbonate of soda or potash can be used to make it alkaline.

Water

Water quality affects both mordanting and dyeing. In most cases soft water with less calcium is preferable, except when dyeing with madder, dyer's seed and brazilwood, which give better results in hard water. You can usually find out what kind of water you have in the area where you live by looking at your local authority's website.

Many people consider that dyeing in rainwater, which is pH neutral, is best of all. If necessary, you can adjust the pH value of rainwater by adding a small amount of an acidic substance (white vinegar, wine vinegar or citric acid) or an alkaline substance (ammonia, bicarbonate of soda or potash) to the bath to compensate.

Other substances in the water, such as iron and copper, can also affect the final result.

Temperature

Wool can tolerate quite high temperatures, but the heat must increase and decrease slowly. If the bath rises above the recommended temperature, remove the pan from the heat and allow it to cool. Avoid stirring when the bath is very hot as that will increase the risk of the yarn felting.

Even though it may be tempting to lift the yarn out immediately, it is best to allow the yarn to cool slowly in the bath. Some dye plants, such as madder, give different shades at different temperatures. This can be useful in order to get several slightly different shades. In each recipe we have included a note of what applies to the colourants concerned.

Time and patience

Possibly the most difficult, yet almost the most important, essential when dyeing is *patience* – allowing everything to take its time.

Let the temperature rise and fall slowly, allow the dyeing to take its time, preferably leave the yarn to cool in the pan, perhaps even overnight. The more time you give your dyeing process, the better the result will usually be; the depth and lightfastness of the colour will increase, which is best for the yarn.

The dyeing process

1. Prepare the yarn by tying the skeins together and maybe marking them with different buttons. Wash the yarn.

2. Mordant the yarn to enable it to absorb the dye. This step may be omitted in some cases. Read about different mordants in the section on mordanting (pages 21–23).

3. Prepare the dyebath.

4. Dye.

5. Afterbath, if desired. An afterbath may be used to adjust the colours and increase lightfastness.

6. Overdye, if desired. It is fun to experiment with several colours on top of one another.

7. Finish, wash and dry.

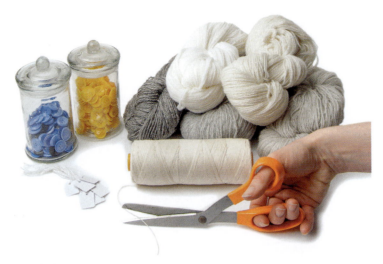

Tie cotton string loosely around the skeins in three or four places. Mark the skeins with buttons of different colours so you can distinguish between the different mordants.

Things to bear in mind for successful dyeing

- Read all the information about preparation and the entire recipe before you start.

- Always ensure good ventilation when you are dyeing and wear a mask and rubber gloves if necessary.

- The proportion of colourant in relation to the quantity of yarn is the important thing; as a rule, the amount of water in the bath does not have so much effect on the strength of the dye. However, it is important that the yarn is not too tightly packed in the bath, which will result in uneven dyeing.

- Because the pigment sinks down in the dyebath from time to time, it is important to stir gently (so that the wool does not felt) from the bottom of the pan, otherwise the result may be uneven.

- As long as pigment remains in the pan, you can use it for more than one bath in order to get paler shades.

- Keep notes of what you do and mark the yarn with information about what it was mordanted and dyed with. It is so easy to forget…

- Never keep botanically dyed yarn in direct sunlight. Also avoid drying the yarn in sunlight.

- Botanical dyeing takes time. Rushing the process usually produces a poorer result.

Preparations

1. Tie cotton string around the skeins in three or four places to prevent them from becoming tangled. Tie the string loosely to allow the dye to penetrate the yarn.

2. If several of you are dyeing together, or if you want to keep different mordantings separate, it is a good idea to mark the skeins, for instance with plastic buttons of different colours.

3. Wash out any wool grease and spinning oil that may be found in the yarn; using an ordinary shampoo works well. The yarn can be dried after washing, but it should be damp when you put it into the pan.

A cautionary example. Immersing for too long in too strong a concentration of iron (ferrous) sulphate has made the yarn rough and brittle.

Mordanting

In order for the dye to attach and last well, the yarn needs to be mordanted, which prepares the fibres to absorb the colour. Mordanting can also be used to control the end result of the dyeing. In the past people used many different chemicals for this, some of which were poisonous. For obvious reasons we have not included them in this book.

It is usually a good idea to mordant a fairly large quantity of yarn in one go. Mordanted yarn can be stored for up to a year before dyeing.

Remember that yarns mordanted in different ways may affect one another if they are placed side by side in the same dyebath.

It is a good idea to label the yarn to remind you how it was mordanted.

If you follow the recipe, the yarn will have absorbed most of the mordant and the water may be poured down the drain. However, we recommend that you save your mordant baths and use them again for your next dyeing session by adding more mordant. This enables you to reduce the amount of mordant that goes to waste and is more environmentally friendly.

Alum and cream of tartar

The substances most commonly used for mordanting are alum (potassium aluminium sulphate) or alum and cream of tartar (potassium bitartrate) together.

Basic recipe for mordanting 300g (10½oz) of woollen yarn

Choose one of these two alternatives:

alum: 60g (2oz) alum
or
alum + cream of tartar: 45g (1½oz) alum + 30g (1oz) cream of tartar
9 litres (2 gallons) hot water (the pan should hold at least 12 litres/2¾ gallons)

Dissolve the alum or alum and cream of tartar in about 200ml (7fl oz) of the hot water.

Add the rest of the water and bring the temperature up to 40°C (104°F).

Add the washed, damp (but squeezed out) yarn to the bath and heat slowly to 85–90°C (185–194°F). Maintain that temperature for 1 hour, stirring gently from time to time.

Allow the yarn to cool in the bath and then let it dry if you are not going to dye it immediately.

Copper sulphate

Copper sulphate comes in the form of odourless blue crystals that can be used as a mordant.

Mordant bath with copper sulphate

2g (¹⁄₁₆oz) copper sulphate
50ml (1¾fl oz) white vinegar
 (concentration: 24%)
3 litres (5¼ pints) water
100g (3½oz) damp yarn

Mix the copper sulphate and vinegar in the water.

Add the yarn and heat the bath slowly to 85°C (185°F). Maintain this temperature for 1 hour.

When the yarn has absorbed all the blue-green colour in the bath and the remaining liquid is almost completely transparent, remove the pan from the heat and leave it to cool.

Mordanting with copper sulphate gives shades that tend towards green and it also improves the lightfastness of the colour.

Copper water and iron water (above)

You can make your own mordant mixtures with copper and iron and so avoid having to wear gloves when handling the poisonous copper sulphate crystals. The metals enable you to get different shades from the dyebath; generally speaking, copper gives more blue-green shades, while iron produces browner or darker shades.

This method is more experimental because it is difficult to measure the precise concentration.

Mordant bath with copper or iron water

Scraps of copper or iron
1 part white vinegar
2 parts water

Place cut pieces of copper piping or other scrap copper in a glass jar with a lid. Add one part white vinegar and two parts water. When the liquid turns blue, which may take a couple of weeks, the mixture is ready to use.

The same method applies to making iron water: place scraps of rusty iron in a lidded jar and add one part white vinegar and two parts water and leave to stand until the liquid turns rust red.

When you have used some of the copper or iron water for a dyebath, just fill the jar up again with more white vinegar and water.

Copper water and iron water can also be used for an afterbath.

Natural mordants

Certain plants and fungi contain substances that act as mordants and if you are dyeing with them you do not need to mordant the yarn.

Acorns

Acorns contain tannins that act as a mordant. You can mordant yarn with them.

Mordant bath with acorns

About 60g (2oz) acorns
9 litres (2 gallons) water
300g (10½oz) woollen yarn

Collect fallen acorns and remove the cups. Crush or chop the acorns coarsely. Simmer them in water for 3–4 hours.
 Strain off the plant material and add a little more water.
 Leave the bath to cool and add the yarn. Slowly bring the temperature up to 85°C (185°F) and maintain that temperature for 1 hour.

Rhubarb leaves

Rhubarb leaves contain oxalic acid, which acts as a mordant. You can mordant yarn with them before dyeing with other colours.

Mordant bath with rhubarb leaves

About 150g (5¼oz) fresh rhubarb leaves
9 litres (2 gallons) water
300g (10½oz) woollen yarn

Cut the rhubarb leaves into pieces and simmer in plenty of water for 1 hour.
 Strain off the plant material and add a little more water.
 Leave the bath to cool and add the yarn. Slowly bring the temperature up to 85°C (185°F) and maintain that temperature for 1 hour.

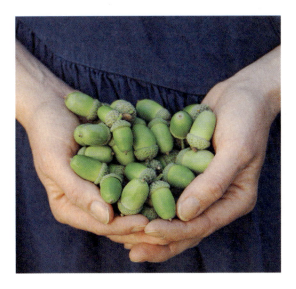

Dye recipes

The recipes in this book only cover a small selection of all the plants, fungi and lichens you can dye with. Our aim was to create a user-friendly handbook that would suit both beginners and those who want to experiment and go more deeply into dyeing. We have chosen recipes based on our own experience and tried to include a variety of colours, methods and combinations that can work at different times of year.

We have decided not to include some traditional dye plants that we think do not give particularly interesting results or have poor lightfastness.

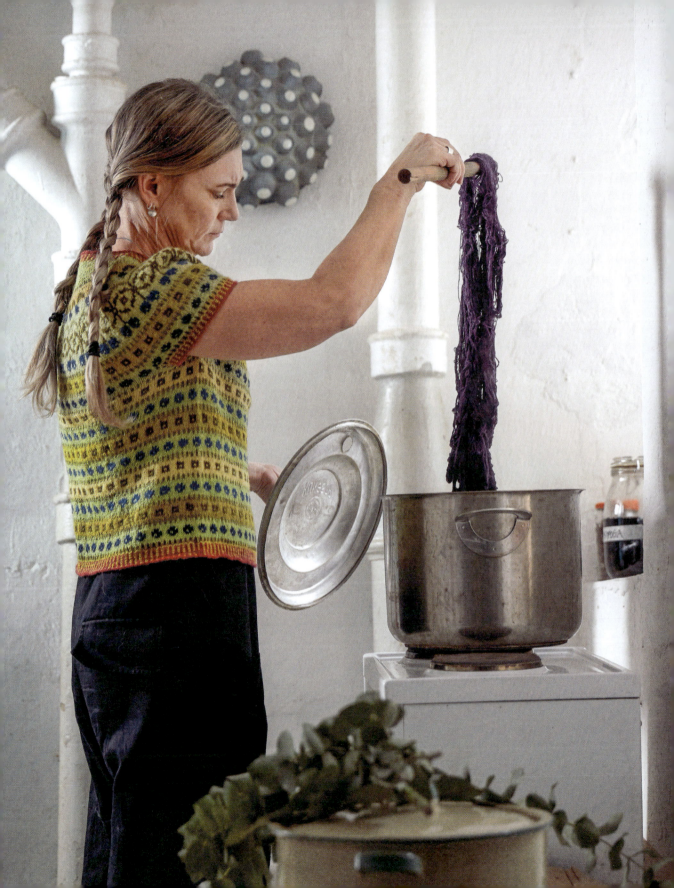

Natural dyes

Natural dyes can be divided into mordant dyes and vat dyes. Most natural dyes are water-soluble mordant dyes, where the yarn is prepared with a mordant in advance so that the dye will attach to it, while indigo and dyes from some lichens are vat dyes. In order to make vat dyes that are soluble in water, you will need what is called a dye vat.

Mordant dyeing

For mordant dyeing, the dye material is finely ground and boiled, usually for under an hour, sometimes longer. The yarn must be prepared with a mordant so that it can absorb the dye. For various methods of mordanting yarn, see page 21.

Vat dyeing

Indigo and some lichens contain pigments that are not soluble in water. These colourants must be reduced (meaning that the oxygen is chemically removed) to make them soluble in water; this process is called vatting. This can be done in slightly different ways: a common method is by fermentation with ammonia or urine. The concentrated vat is then diluted in a dyebath.

With vat dyeing, the dyebath is not the colour that the fibres will become. During dyeing the material being dyed will take on the colour of the bath, but when it later oxidizes in contact with the oxygen in the air, the colourant is regenerated and regains both its colour and its water-insoluble chemical structure. The pigment is now 'locked' around the fibres, so vat dyed colours are usually very lightfast and the indigo pigment also strengthens the fibres.

When dyeing with indigo, the oxidization is the moment of magic; when you lift out the yarn and shake it in the air, the colour is transformed from yellow-green to blue in the twinkling of an eye.

> If you do not want to use ammonia, you can use your own urine. Collect a few hundred millilitres in a resealable plastic bag or a lidded jar and place it in a sunny spot for two weeks. The fermentation process concentrates the ammonia in the urine.

Our recipes are divided into the following categories: plants, fungi and lichens. All the recipes may be doubled or trebled if you desire. Usually we also offer suggestions for variations so that you can produce many subtle shades or even different colours from the same colourant.

That's it, off we go!

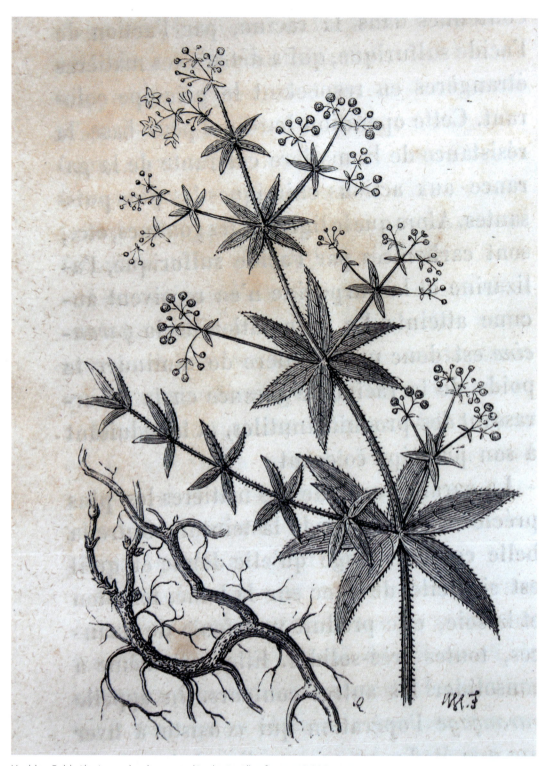
Madder, *Rubia tinctorum*, has been used to dye textiles for over 3,000 years.

Dyeing with plants

It is a bit difficult to say precisely how much plant material you need. It depends on the plant in question and what shade you are aiming for, but approximately half as much plant material as yarn will produce a weak bath, equal proportions of plant and yarn will produce a medium bath and twice as much plant as yarn will produce a strong bath. A concentrated bath will naturally result in a stronger dye.

When it comes to dried plants, the proportions will be about the same in weight, because dried material loses both colour intensity and weight.

Cut or chop the fresh plants into fairly small pieces, place them in a pan and cover with water. Fresh plants shrink a lot when boiled, so if you do not have room for everything to begin with, you can top up the pan as required.

Dried plants sometimes need to soak before being used for dyeing.

If you are not sure whether or not a plant is a dye plant, you can do a microtest: place pieces of the chopped plant in a bowl with a little water and a scrap of yarn (preferably a mordanted yarn) and pop it in the microwave for about 30 seconds. If the yarn has absorbed the colour it may be worth investigating the plant more closely!

If you are unsure about a plant you have come across and do not have a field guide with you, there are now apps, such as PictureThis and PlantSnap, that will help you to identify it.

Carl Linnaeus (1707–1778)

The leading botanist of his day, Carl Linnaeus drew up a system for classifying and naming plant species that is still used in the scientific world today. He gave a number of well-known dye plants and lichens the species name *tinctoria* or *tinctorius*, which means 'dyeing'.

Species	Scientific name
Dyer's alkanet	*Alkanna tinctoria*
Dyer's greenweed	*Genista tinctoria*
Dyer's knotweed	*Persicaria tinctoria*
Dyer's plumeless saw-wort	*Serratula tinctoria*
Dyer's tickseed	*Coreopsis tinctoria*
Golden marguerite	*Cota tinctoria*
Indigo	*Indigofera tinctoria*
Madder	*Rubia tinctorum*
Old fustic or dyer's mulberry	*Maclura tinctoria*
Safflower	*Carthamus tinctorius*
Woad	*Isatis tinctoria*
Roccella lichen	*Roccella tinctoria*
Palm ruffle lichen	*Parmotrema tinctorium*

Madder

Rubia tinctorum

Colours: **orange, red-brown, aubergine and salmon pink**
Parts used for dyeing: **roots**
Lightfastness: **exceptional (6)** – see page 17

Madder is one of the oldest and most important dye plants. Traces of madder red have been found in Tutankhamun's tomb from the 14th century BCE. Madder came to Europe from the Holy Land with the Crusaders in the 13th century. It has been a well-known dye plant for a long time and Linnaeus gave it the Latin name *Rubia tinctorum*, which means 'dyer's red'.

Madder is a yellow-flowered dye plant, the roots (rhizomes) of which produce a red colour. It contains the red colourant alizarin, along with small amounts of yellow and brown colourants.

You can certainly grow madder yourself, but it takes several years to grow and collect enough to dye with, so it is easier to buy it. It is available both ground and as whole dried roots.

If you want to try to grow it yourself, buying established plants rather than growing from seed can be a shortcut. The plants like to be sited in a sunny spot. They easily seed themselves so new seedlings will probably appear in the next season.

You can also collect and dry the fruits that contain the seeds. These can be sown indoors in early spring and planted out when the risk of frost has passed.

During the growing season you can have a go at dyeing with madder sprigs and leaves, which will produce shades of salmon pink.

Dig carefully when you harvest the roots to enable your madder plants to survive. The roots can be long and grow to around 8mm (5/16in) in diameter. They are easily recognizable because they are bright red.

Madder produces warm shades of red and orange, depending on the mordant used and the temperature of the bath.

Red-orange shades: mordanting with alum, 60°C (140°F).

Red shades: mordanting with alum and cream of tartar, 60°C (140°F).

Red colours: alkaline bath at max 60°C (140°F).

Red-brown colours: high temperatures up to 85°C (185°F), maintain for 1 hour.

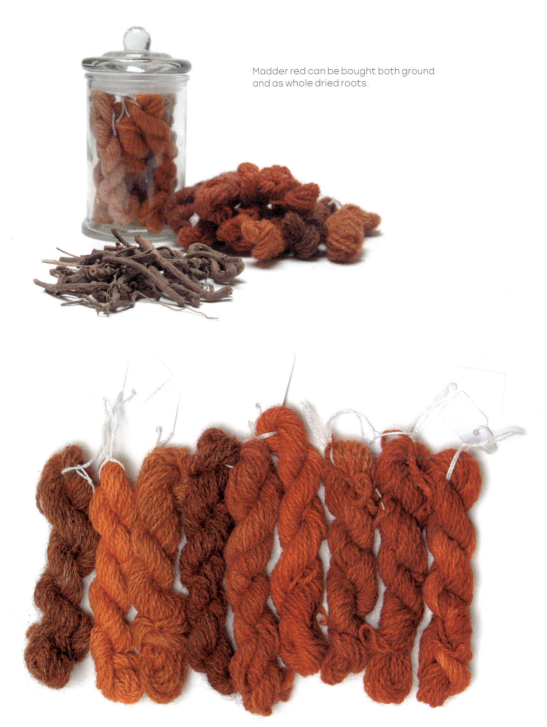

Madder red can be bought both ground and as whole dried roots.

Yarn dyed with madder at 60°C (140°F).

Aubergine: afterbath with iron (ferrous) sulphate or iron water in a bath with a high pH (alkaline).

Salmon pink shades: afterbath with copper sulphate or copper water.

A bath with something acidic added produces brighter colours tending towards yellowy orange.

Adding a bottle of dark beer or stout to the bath is an old trick that makes the red colour deeper.

Add a dash of white vinegar to the last rinse (if you have not raised the pH level).

To get deeper red colours, dye for 1 hour at 60°C (140°F), allow the yarn to dry and then soak and dye again for another hour at 60°C (140°F).

You can usually use one madder bath up to three times to dye wool; the last bath usually produces a pretty shade of salmon pink.

To extract the last of the dye from a madder bath, for example after the third bath, add 1tbsp of citric acid (pH 4) to it. Then add the yarn and keep the temperature at 85°C (185°F) for 1 hour – the yarn will take on a strong orange colour.

Madder can produce aubergine and salmon pink colours if you use different afterbaths.

Dyebath

50g (1¾oz) ground dried madder
1tsp potash or bicarbonate of soda (if you want a higher pH value)
3–5 litres (5¼–8¾ pints) water
1 bottle dark beer or stout (optional)
100g (3½oz) mordanted woollen yarn
Rinse: white vinegar

Soak the ground dried roots overnight. Add 1tsp potash or bicarbonate of soda to the water to raise the pH level, because the colourant alizarin is released better in alkaline baths.

Mix this paste with 3 litres (5¼ pints) of water.

Add the damp, mordanted yarn and bring the temperature up slowly to a maximum of 60°C (140°F) for red shades or 85°C (185°F) for red-brown shades. Maintain this temperature for 1 hour.

Leave the yarn to cool in the bath, preferably overnight.

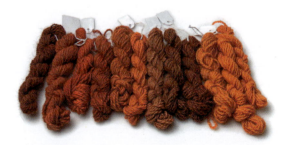

Yarn dyed with madder at 85°C (185°F) comes out in red-brown shades. Adding something acidic will produce shades of orange.

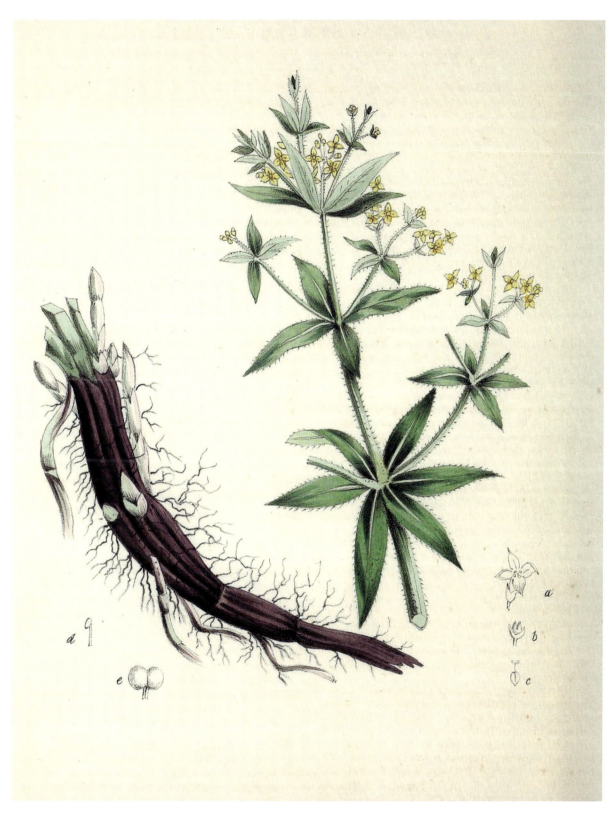

Beetroot

Beta vulgaris

Colours: **cool, deep red colours**
Parts used for dyeing: **beetroot**
Lightfastness: **excellent (5)**

Beetroot contains the bright red colourant betanin, which is often used as a food dye. Despite its bright colour it is difficult to make it fix permanently on textiles. This recipe using oven-baked beetroot comes from Lisa Johansson's book *Gamla, i Lappmarken kända växtfärgningsrecept* (translated as, *Old, well-known plant-dyeing recipes from Lapland*) and it works really well.

It is a good idea to use beetroot that has been lying around in the fridge and shrivelled a bit.

Dyebath

2–3 beetroot
3–5 litres (5¼–8¾ pints) water
100ml (3½fl oz) white spirit vinegar (12%)
 or 50ml (1¾fl oz) acetic vinegar (24%)
100g (3½oz) mordanted yarn
Rinse: white vinegar

Scrub the beetroot clean and bake in the oven at 200–225°C (390–440°F) until soft.

Cut the beetroot into fairly small pieces and put them in a stainless steel or enamel pan or a large glass jar with a lid.

Pour in the water and vinegar and mix well.

Leave to stand for 3–4 days, preferably in a warm place.

Stir again and add the mordanted yarn.

Stir to ensure that the dye is absorbed evenly and leave to stand for a further 3–4 days.

Add a dash of white vinegar in the last rinse.

Lisa Johansson

Lisa Johansson (1894–1982) was an author and textile artist working in Vilhelmina in the Swedish county of Västerbotten, who depicted the life and customs of working people. She documented the everyday life of what was then known as Swedish Lapland for the Nordic Museum in Stockholm and the Dialect and Folklore Archive in Uppsala. She also noted down hundreds of old botanical dyeing recipes, which are collected in the book *Gamla, i Lappmarken kända växtfärgningsrecept*, first published in 1948.

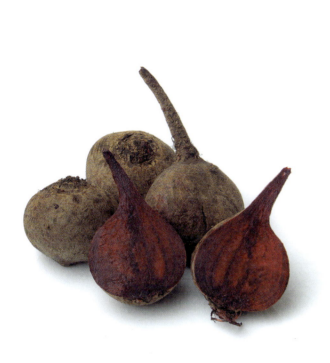

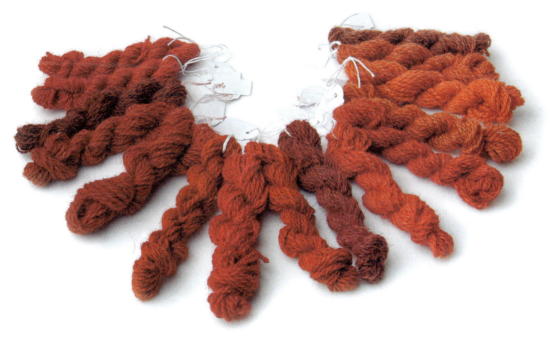

Plum

Prunus domestica

Colours: **warm orange-pink shades**
Parts used for dyeing: **bark**
Lightfastness: **good (4)**

Remember to keep cut branches and twigs when fruit trees are pruned in July, August and September, because you should use the bark from fresh (not rotten) branches. Strip the bark off the twigs and leave it to dry. It can be kept for quite a long time.

The yarn will not need to be mordanted.

Use half the amount of bark to yarn for a stronger colour.

Dyebath

50g (1¾oz) dried bark
3–5 litres (5¼–8¾ pints) water
100g (3½oz) yarn, mordanted or unmordanted
Rinse: white vinegar

Before dyeing soak the bark for at least 24 hours, preferably a week.

Simmer the bark (do not boil it!) in water for 1 hour.

Strain off the bark and add more water to the pan if a lot has evaporated.

Add the yarn and maintain the temperature at 85°C (185°F) for 1 hour.

Leave the yarn to cool in the bath, preferably overnight.

Add a dash of white vinegar in the last rinse.

The bark of cherry, almond, apricot and peach trees can be used in the same way and gives various shades of soft pink. Note that the bark must never boil, only simmer.

The leaves of these trees can also be used to create yellow and olive green shades. Follow the same recipe as for dyeing with birch leaves (see page 40).

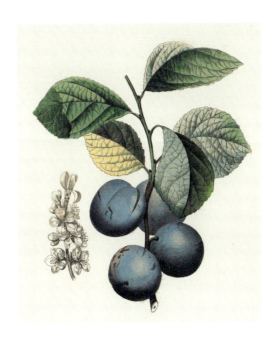
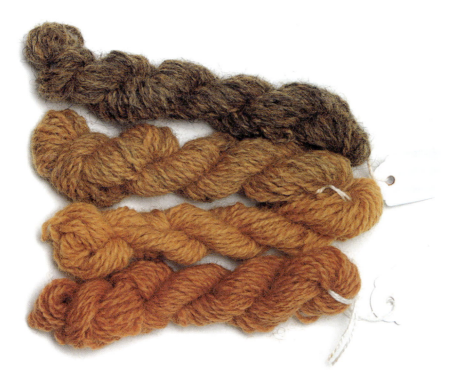

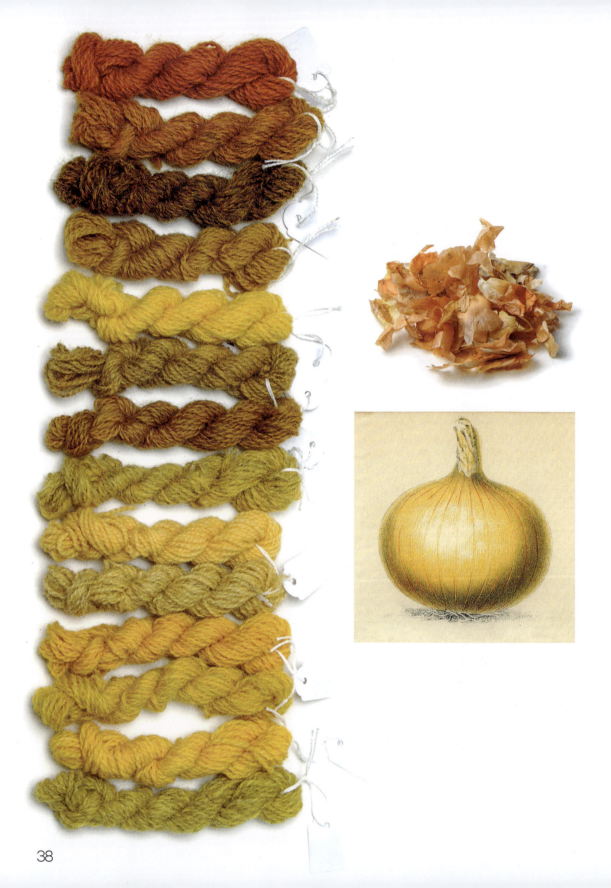

Yellow onion

Allium cepa

Colours: **shades of yellow**
Parts used for dyeing: **dry, rustly outer skins**
Lightfastness: **good (4)**

Dyeing with onion skins is a safe bet. If you have never done any dyeing before, onion skins are just the thing for your first attempt. At home, it is easy to save onion skins from cooking. The best thing to do is to store them in the freezer. You can also go to a supermarket or grocery store and ask if you can empty the 'skin bins' under the onions in the vegetable section.

Dyebath

50g (1¾oz) onion skins
3–5 litres (5¼–8¾ pints) water
100g (3½oz) mordanted yarn
1tsp ammonia or bicarbonate of soda (if you want a higher pH value)
Rinse: white vinegar

Boil the onion skins in water for 1 hour and strain off the plant material. You can save this and boil it again for another dyebath.

Let the bath cool and add the damp mordanted yarn. Bring the temperature slowly up to 85°C (185°F) and maintain this temperature for 1 hour. For brighter shades of yellow, increase the pH value by adding 1tsp of ammonia or bicarbonate of soda during the last 10 minutes of dyeing.

Rinse the yarn until the rinsing water is clear.

Add a dash of white vinegar to the last rinse unless you raised the pH level during dyeing.

You can usually use the onion bath to dye more than one batch.

> For shades of orange, double or treble the quantity of onion skins in proportion to the amount of yarn.

> An afterbath with copper water or copper sulphate produces greener shades and increases lightfastness.

Birch

Betula (all species)

Colours: **yellow and yellow-green shades**
Parts used for dyeing: **leaves**
Lightfastness: **moderate-good (3-4)**

Birch are common deciduous trees found throughout the northern hemisphere, and they are easily recognized thanks to their white trunks with black patches. There are 40 species of birch, all of which are good for dyeing, but the dwarf birch is said to produce the strongest colours.

Leaves gathered during the early summer produce the strongest dye that is less likely to fade, but you can use foliage collected at any time during the season.

Birch leaves produce a lovely clear yellow colour that is moderately lightfast, but dyeing in a copper pan and adding copper sulphate will give you yellow-green shades that are more lightfast.

Dyebath

200g (7oz) birch leaves
3-5 litres (5¼-8¾ pints) water
100g (3½oz) mordanted yarn
2.5g (1/16oz) copper sulphate (optional)
Rinse: white vinegar

Pull the leaves off the twigs and place them in a pan (preferably a copper pan) and add just enough water to cover them. Boil the leaves for 1 hour and then strain them off.

Add more water if a lot of it has evaporated, so that you have 3-4 litres (5¼-7 pints) of water in the pan.

Allow the bath to cool to about 50°C (122°F), add copper sulphate if desired, then add the damp, mordanted yarn.

Slowly raise the temperature to 85-90°C (185-194°F) and maintain this temperature for 1 hour. Leave the yarn to cool in the bath, preferably overnight.

Add a dash of white vinegar in the last rinse.

> **Yellow shades:** yarn mordanted with alum or alum and cream of tartar in a stainless steel or enamel pan.

> **Yellow-green shades:** yarn mordanted with alum or alum and cream of tartar in a copper pan with the addition of copper sulphate (may be substituted with copper water, see page 22).

Grey-green shades: afterbath with iron water.

Olive green shades: afterbath with copper.

Warm yellow colours: mordanting with potash – place damp yarn in cold water with 1–2g (1/32–1/16oz) of potash per litre (2 pints) of water and leave to stand for 2 hours. Then put the yarn in the dyebath.

Green colours: dye on grey marl yarns.

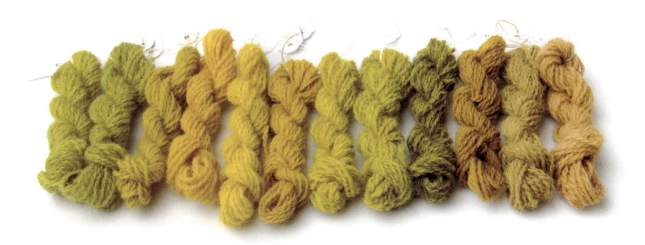

Red onion

Allium cepa

Colours: **shades of green**
Parts used for dyeing: **dry, rustly outer skins**
Lightfastness: **excellent (5)**

Strangely enough, red onion produces shades of green, despite the fact that the dyebath looks red.

Save onion skins from your cooking or ask if you can take some from the 'skin bins' under the onions in your local supermarket.

Dyebath

50g (1¾oz) onion skins
3–5 litres (5¼–8¾ pints) water
100g (3½oz) mordanted yarn
1tsp ammonia, potash or bicarbonate of soda
 (if you want a higher pH value)
Rinse: white vinegar

Boil the onion skins in water for 1 hour and strain off the plant material. You can save the skins and boil them again for another dyebath.

Allow the bath to cool and add the damp, mordanted yarn. Slowly bring the temperature up to 85°C (185°F) and maintain this temperature for 1 hour.

Allow the yarn to cool in the bath, then rinse.

Add a dash of white vinegar to the last rinse (if you did not raise the pH level during dyeing).

You can dye more than one batch in the onion bath, but each bath will be less lightfast.

Darker green: double or treble the proportion of onion skins to yarn.

Adding 1tsp ammonia, potash or bicarbonate of soda for the last 10 minutes gives lighter lime shades.

An afterbath containing copper water or copper sulphate gives greener shades and increases lightfastness.

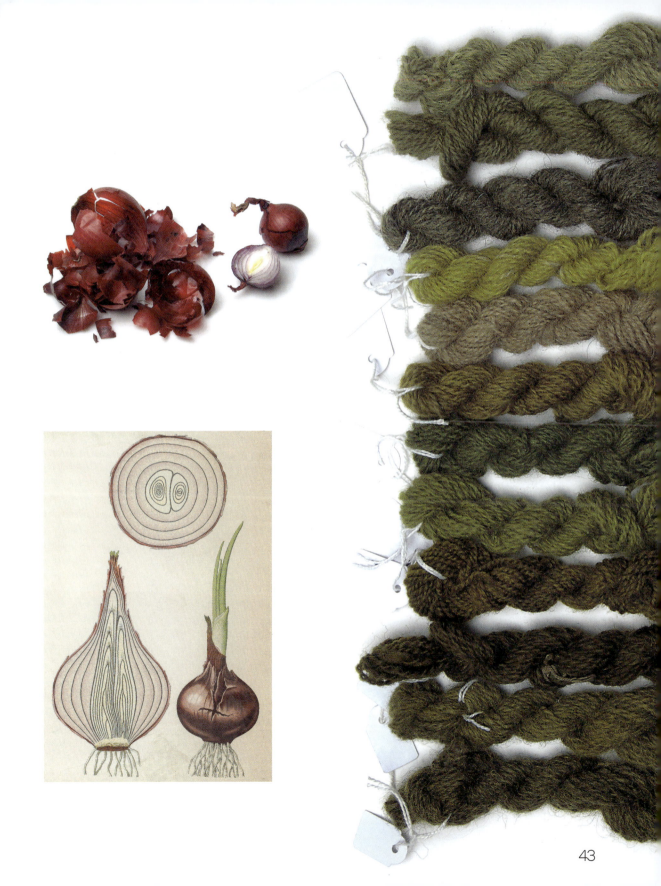

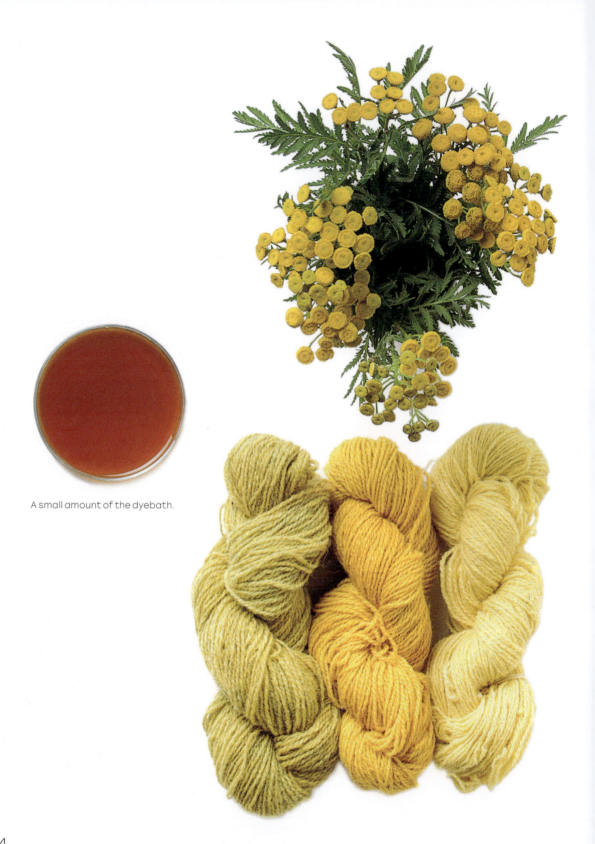

A small amount of the dyebath.

Tansy

Tanacetum vulgare

Colour: **yellow**
Parts used for dyeing: **flowers or the entire plant**
Lightfastness: **good (4)**

Tansy is easily recognized by its button-shaped flowers and characteristic scent. It is a common plant and is often seen along the edges of ditches. It flowers from high summer to early autumn.

The whole plant produces yellow dye, but if you use only the flowers you will get even brighter yellows. Tansy can be used fresh or dried.

Dyebath

100g (3½oz) plant material
3–5 litres (5¼–8¾ pints) water
100g (3½oz) mordanted woollen yarn
1tsp ammonia, bicarbonate of soda or potash
 (if you want a higher pH value)
Rinse: white vinegar

Simmer the tansy in the water for 1 hour, then strain off the plant material.

Allow the bath to cool to about 40°C (104°F) before adding the yarn and increase the temperature to 85°C (185°F) for 1 hour. Leave the yarn in the bath while it cools.

Rinse the yarn with a dash of white vinegar in the last rinse (if you have not raised the pH level).

A teaspoon of ammonia, bicarbonate of soda or potash in the bath for the last 10 minutes gives more golden shades.

An afterbath containing iron water gives shades of olive green (see page 22).

Golden marguerite

Cota tinctoria

Trade name: **Anthemis tinctoria**
Colours: **yellow to yellow-green**
Parts used for dyeing: **flowers (bright yellow) or the entire plant (yellow-green)**
Lightfastness: **good (4)**

Golden marguerite grows wild in Europe, and can also be grown from seed. It flowers from June to September and is usually picked when the flowers have just begun to wilt. It can be used fresh or dried.

The entire plant can be used for dyeing, but using just the flowers gives a brighter yellow colour. If you like, you can dye with the flowers in one batch and the stems with their leaves in a separate batch, and thus get a greater variety of subtle shades.

Flowers alone give bright yellow colours.

The whole plant produces yellow-green colours.

Dyebath

100g (3½oz) plant material
3–5 litres (5¼–8¾ pints) water
100g (3½oz) mordanted yarn
Rinse: white vinegar

Simmer the plant material in the water for 1 hour, then strain off the plant material.
 Add more water if a lot of water has evaporated.
 Allow to cool and add the damp, mordanted yarn.
 Slowly raise the temperature to 85°C (185°F) and maintain this temperature for 1 hour. Allow the yarn to cool in the bath.
 Add a dash of white vinegar in the last rinse.

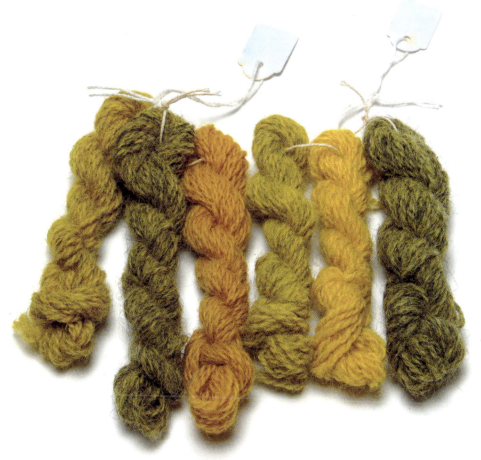
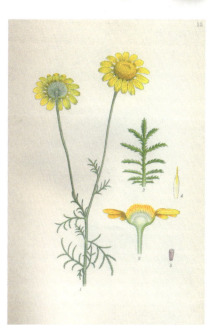 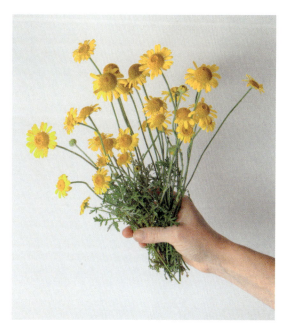

Goldenrod

Species in the genus *Solidago*

Colours: yellow
Parts used for dyeing: flowers and/or the entire plant
Lightfastness: good (4)

There are over 80 species of goldenrod. The most commonly found are the giant goldenrod, *Solidago gigantea*, and Canadian goldenrod, *Solidago canadensis*, both of which are common in gardens, the edges of ditches, railway embankments and on waste ground. They are distinguished by their large flower clusters with many small flowers on a tall upright stem. Canadian goldenrod is considered to be invasive, so you do not have to worry about picking a lot of it.

All species of goldenrod are good for dyeing and you can also combine them. They flower from high summer into the autumn.

Dyebath

100g (3½oz) flowers and/or the entire plant
3–5 litres (5¼–8¾ pints) water
100g (3½oz) mordanted yarn
Rinse: white vinegar

Simmer the goldenrod in the water for 1 hour, then strain off the plant material. Add more water if a lot has evaporated and allow to cool.

Add the damp, mordanted yarn, bring the temperature slowly up to 85°C (185°F) and maintain this temperature for 1 hour.

Leave the yarn to cool in the bath.

Add a dash of white vinegar in the last rinse.

Canadian goldenrod (left) and giant goldenrod (right).

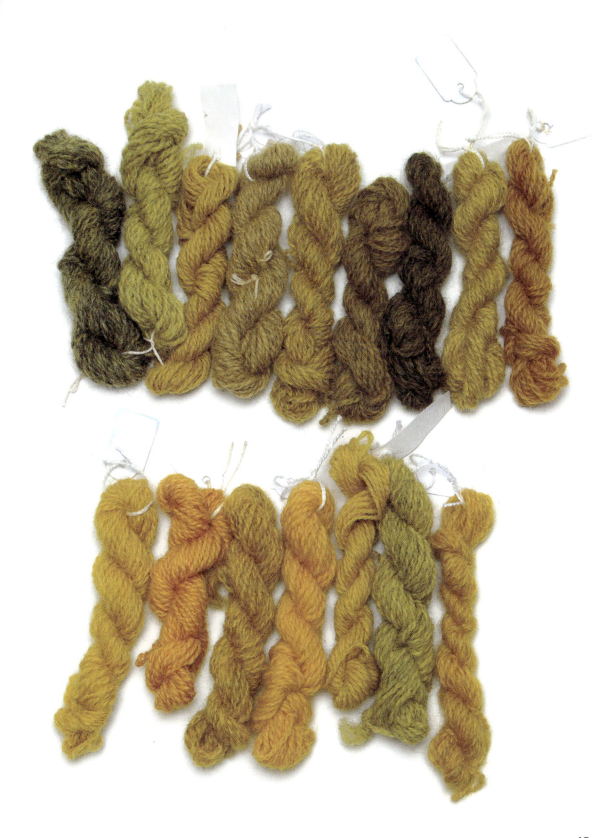

Rhubarb

Rheum rhabarbarum

Colours: **golden yellow or rust red**
Parts used for dyeing: **the root**
Lightfastness: **excellent (5)**

Rhubarb is an edible perennial that many people have in their gardens. It has thick, fleshy roots which reach deep into the soil. Presumably you will not want to sacrifice your entire stock of rhubarb for dyeing, but if you happen to dig up a root you can save it. If you do not want to dye with it immediately, it is fine to dry it.

The roots produce a warm golden yellow colour. The leaves can also be used for dyeing but do not give such a strong colour.

Dried, ground rhubarb root, known as Indian rhubarb, is also available to buy. It must be soaked for 24 hours before dyeing.

Rhubarb root is long-lasting and you can dye many times using the same bath.

Mordanting is not necessary, but you can do this to get other subtle shades. Mordanting with alum gives a warm yellow colour.

Dyebath

About 500g (1lb 1½oz) fresh or dried, chopped rhubarb root or 30–100g (1–3½oz) dried, ground root
3–5 litres (5¼–8¾ pints) water
100g (3½oz) mordanted or unmordanted yarn
1tsp ammonia, bicarbonate of soda or potash (if you want a higher pH value)
Rinse: white vinegar

Put the chopped rhubarb root in a pan and add the water. Boil for at least 1 hour.

It is fine to leave the pieces of plant in the bath during dyeing. Add more water if some has evaporated, so that you have 3–5 litres (5¼–8¾ pints) of water.

When the bath has cooled, add the damp yarn and slowly raise the temperature to 85–90°C (185–194°F) over the course of 1 hour. Preferably leave the yarn in the pan until the bath has cooled.

Rinse the yarn with a dash of white vinegar in the last rinse (if you have not raised the pH level).

> If you raise the pH by adding 1tsp ammonia, bicarbonate of soda or potash to the bath, you will get rust-red colours.

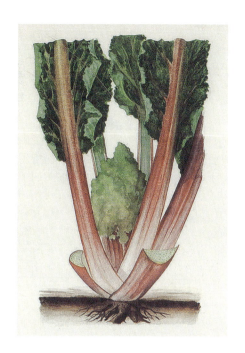

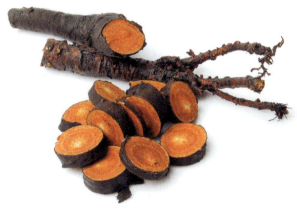

Rhubarb has surprisingly bright orange roots.

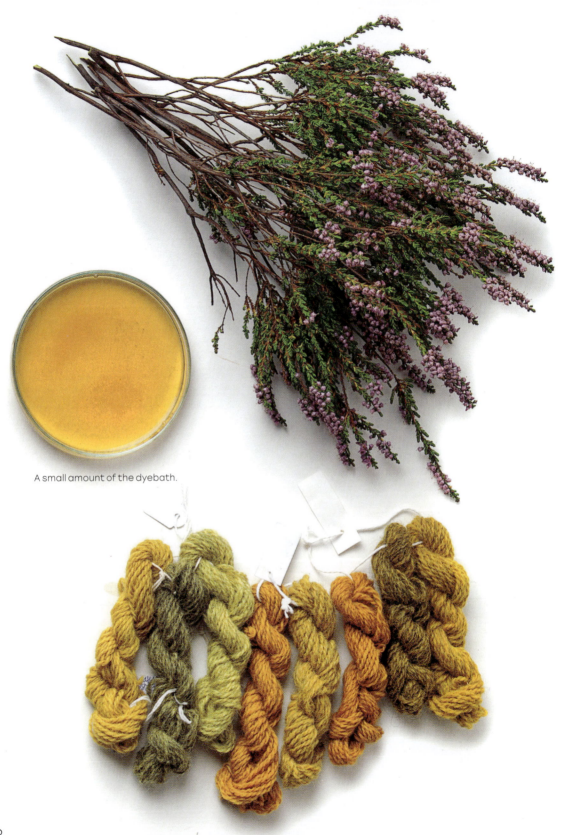

A small amount of the dyebath.

Heather

Calluna vulgaris

Colours: **rust or orange (flowers), yellow and yellow-green (whole plant)**
Parts used for dyeing: **flowers or the whole plant**
Lightfastness: **good (4)**

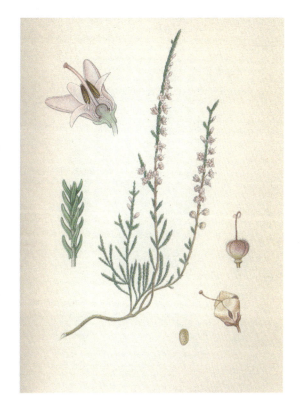

Heather is a common plant in upland areas, and is also grown in gardens. It produces various colours, depending on whether it is picked early or late in the season.

Dyeing with just the flowers gives shades of rust or orange, while dyeing with the entire plant produces yellow and yellow-green shades.

Dyeing in a copper pan will produce deeper shades.

Dyebath

100g (3½oz) plant material
3–5 litres (5¼–8¾ pints) water
100g (3½oz) mordanted yarn
Rinse: white vinegar

Boil the water and plant material for 1 hour. Strain off the plant material and allow the bath to cool to about 40°C (104°F).

Add the damp, mordanted yarn. Increase the temperature slowly to 85°C (185°F) and maintain this temperature for 1 hour.

Add a dash of white vinegar in the last rinse.

Dyer's weed

Reseda luteola

Colour: **yellow**
Parts used for dyeing: **entire plant**
Lightfastness: **exceptional (6)**

Dyer's weed, also known as weld, grows wild in Europe and was cultivated as a dye plant in the Roman Empire. According to legend it was used to dye the tunics of the vestal virgins, the priestesses of the goddess Vesta, whose duty it was to tend the holy fire in the temple of Vesta.

If you do not want to buy dried dyer's weed, you can try to grow it yourself. Sow the seeds indoors in small pots in early spring and plant them out when the risk of frost is over. If you do not want to dye with them immediately, it is fine to cut the plants and dry them. It is a biennial plant, so it will come back in the same place next year.

Dyer's weed contains the yellow pigment luteolin, which is found in all parts of the plant and is considered to give the most lightfast yellow colour of all plants.

Dyebath

100g (3½oz) dried or about 200g (7oz) fresh dyer's weed
3–5 litres (5¼–8¾ pints) water
100g (3½oz) mordanted yarn or bicarbonate of soda (if you want a higher pH value)
Rinse: white vinegar

Soak dried dyer's weed overnight. If you are using fresh dyer's weed, cut it into fairly small pieces.

Add more water and simmer gently for 1 hour, making sure that it does not boil, as that can make the colour more subdued. Strain off the plant material.

Allow the bath to cool and add the damp, mordanted yarn. Increase the temperature slowly to 70°C (158°F) and maintain this temperature for 1 hour.

It is important to stir the bath occasionally during the whole dyeing process, as the pigment tends to sink to the bottom.

Rinse the yarn with a dash of white vinegar in the last rinse (unless you raised the pH level in the dyebath).

> Adding 1tsp ammonia, potash or bicarbonate of soda in the dyebath for the last 10 minutes will produce a brighter yellow.

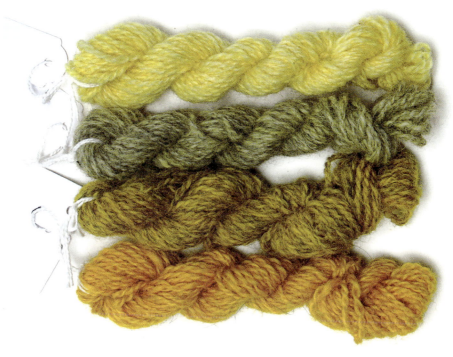

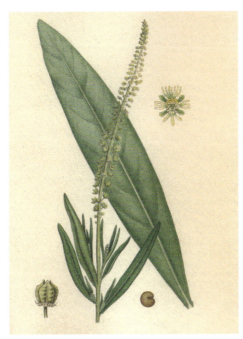

Dried dyer's weed needs to soak overnight before dyeing.

Eucalyptus

Eucalyptus, several species

Colours: **yellow and orange**
Parts used for dyeing: **leaves and stems**
Lightfastness: **excellent (5)**

There are over 600 species and hybrids of eucalyptus; some thrive best in a tropical climate, some in a dry, desert climate, while others, for example *Eucalyptus perriniana*, are suited to a colder climate. This means you can grow it yourself or you can easily buy it from a florist's shop, as it is a common feature in bunches of flowers. The additional advantage of this is that you can dye with it all year round. It can be used fresh or dried.

Eucalyptus will produce a great variety of colours, depending on the mordant and afterbath, but you will need to be extra-patient, because preparations have to be made the day before and then the actual dyeing takes 3–4 hours. Do not lose heart; the colour does not start to become visible in the yarn until after at least 2 hours!

Unmordanted yarn: yellow, yellowy-orange

Yarn mordanted with alum: yellow, yellowy-orange

Yarn mordanted with alum and cream of tartar: bright orange, mandarin

Grey yarn: green, lime

Afterbath with iron (ferrous) sulphate: plum

Afterbath with copper: olive green shades

Adding 10g (⅜oz) cream of tartar to the dyebath from the start will give you brighter shades of orange.

Dyebath

200g (7oz) plant material
3–5 litres (5¼–8¾ pints) water
100g (3½oz) mordanted or unmordanted yarn
Rinse: white vinegar (if you have not raised the pH value)

You can use a copper pan for darker colours.

Cut the leaves and stalks in pieces and place in a pan, add boiling water and leave to stand overnight.

Simmer the plant material for 1 hour, then reduce the temperature to 40°C (104°F) before adding the yarn.

Add the damp yarn. Bring the temperature slowly up to 85°C (185°F) and maintain this temperature for 3–4 hours.

The plant material can remain in the bath to produce brighter colours, but remember to stir gently from time to time, to prevent uneven dyeing.

The yarn absorbs almost all of the dye in the first bath so it is not usually worth re-using it for more dyeing, but as eucalyptus is relatively easy to get hold of, you can experiment with new baths.

Rinse the yarn with a dash of white vinegar in the last rinse (if you have not raised the pH level).

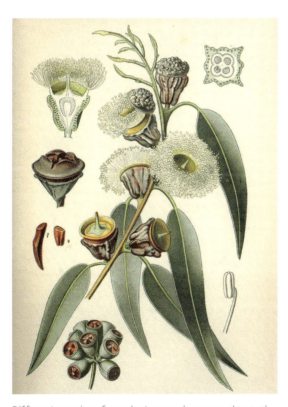

Different species of eucalyptus may have round or oval leaves, but they are all good for dyeing.

Although the dyebath looks almost red, the yarn turns green.

Common reed

Phragmites australis

Colours: **shades of green**
Parts used for dyeing: **the panicles – the flower heads of the reeds**
Lightfastness: **excellent (5)**

The reddish-violet flower heads of reeds are called panicles. Common reed grows around the edges of lakes and ponds, in wetlands and along river banks. It can be picked during the late summer and early autumn. It is fine to use it straight away, and it can also be frozen, but not dried.

It is not known for certain how long people have been dyeing with reed flower panicles, but recipes can be found in books dating back to the mid-18th century.

Reed panicles have been used for dyeing in rural areas, but not by professional dyers.

The panicles produce shades of green.

Dyebath

450g (1lb) reed panicles
3–5 litres (5¼–8¾ pints) water
100g (3½oz) mordanted yarn
If desired, 1tsp ammonia, bicarbonate of soda or potash (for lime green shades)
Rinse: white vinegar

Cut the panicles into fairly small pieces, add the water and boil for 1 hour, preferably in a copper pan. Strain off the plant material.

Allow the bath to cool and add the damp mordanted yarn. Bring the temperature slowly up to 85°C (185°F) and maintain this temperature for 1 hour. Leave the yarn to cool in the bath.

Rinse the yarn with a dash of white vinegar in the last rinse (if you have not raised the pH level).

> Adding 1tsp of ammonia, bicarbonate of soda or potash to the bath during the last 10 minutes of dyeing will create more of a lime green colour.

> An afterbath with copper water or copper sulphate makes the green colour stronger and more lightfast.

Brazilwood

Paubrasilia echinata

Colours: **plum, red and orange**
Parts used for dyeing: **wood**
Lightfastness: **excellent (5)**

The name Brazilwood is most commonly applied to the flowering tree *Paubrasilia echinata*, a member of the legume family that is native to the Atlantic forests of Brazil. Brazilwood found its way to Europe following the discovery of the New World. The Portuguese even named their new colony *Terra do Brasil* (Land of the Brazil tree) after the prized commodity, and it is now that country's national tree.

Prior to that, the wood of a related Asian tree, known as the sappanwood, was used for dyeing similar shades of red. It was imported to Europe from the East Indies and India and was first mentioned as a dye as early as 1321.

The word '*echinata*' in the Latin name means 'spiny' and refers to the thorns that cover all parts of the tree, including the bark and fruits. The colourant it contains is known as brasilin. Brazilwood does not grow in Europe or North America, so you will have to buy the pigment.

Dyebath

20g (¾oz) powdered Brazilwood
3–5 litres (5¼–8¾ pints) water
100g (3½oz) mordanted yarn
1tsp ammonia, potash or bicarbonate of soda (if you want to raise the pH)
or
1tbsp white vinegar or citric acid (if you want to lower the pH)
Rinse: white vinegar

Place the powdered brazilwood in about 350ml (⅝pint) of the water and simmer for 1–3 hours. Leave to stand overnight, or longer if you like. Add the rest of the water.

Add the damp yarn to the bath, slowly raise the temperature to 85°C (185°F) and maintain this temperature for 1 hour.

Leave the yarn in the bath to cool, preferably overnight.

Allow the yarn to dry completely before washing out the dye.

Add a dash of white vinegar to the last rinse.

> For a plum colour: raise the pH by adding 1tsp ammonia, potash or bicarbonate of soda to the bath.

> For orange colours: lower the pH value by adding 1tbsp of white vinegar or citric acid to the bath.

> For really strong red colours: use equal quantities of yarn and colourant.

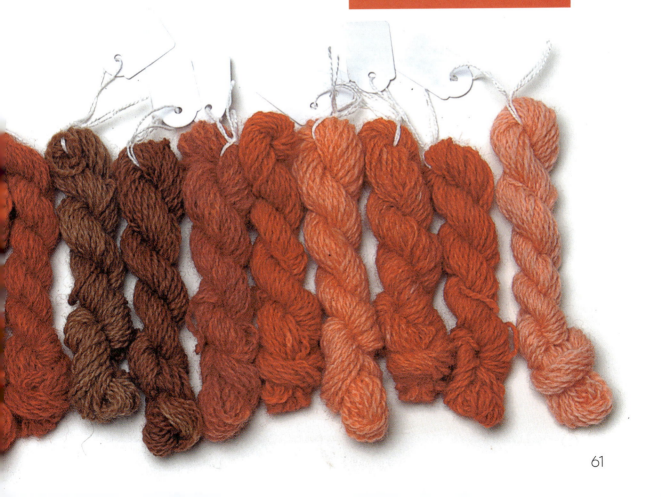

Logwood is available in powder form or as dried chips.

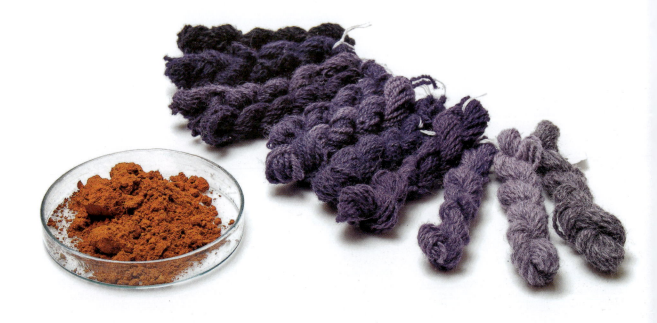

Logwood

Haematoxylum campechianum

Colours: **blue, blue-purple and black**
Parts used for dyeing: **wood**
Lightfastness: **good (4)**

Logwood is the wood of the tree *Haematoxylum campechianum*, which is native to Central America and Mexico. The dye produced from it became one of Spain's major imports to Europe after the 'discovery' of America. The dye is extracted from the heartwood and, together with iron (ferrous) sulphate, it produces a much-coveted black colour.

The dye is very long-lasting and you can get many baths from one preparation.

Its lightfastness is not the best, but can be improved by an afterbath of copper or iron.

- Mordanting with alum: purple shades
- Mordanting with alum and cream of tartar: tends more towards brown
- Afterbath with copper sulphate: tends more towards blue
- Afterbath with iron (ferrous) sulphate: tends more towards plum-black

Dyebath

25g (1oz) dried, powdered logwood or 50g (1¾oz) dried chips
3–5 litres (5¼–8¾ pints) water
100g (3½oz) mordanted yarn
1tsp bicarbonate of soda, ammonia or potash (if you want to raise the pH)
Rinse: white vinegar (if you have not raised the pH)

Soak the powdered or chipped logwood in a little water for at least 48 hours. The dye is best extracted in a small amount of alkaline water, so preferably add 1tsp bicarbonate of soda, ammonia or potash to the bath.

Simmer for 30 minutes and then strain off the plant material. The chips can be saved and used again for another dyebath.

Add the rest of the water and the damp yarn and heat slowly to 85°C (185°F). Maintain this temperature for 1 hour. Do not rinse the yarn the same day but leave it in the bath overnight. Hang it up to dry for at least 48 hours before washing it out.

If you have not raised the pH, you can add a dash of white vinegar to the last rinse. The colour will be more lightfast and less likely to rub off.

Red cabbage

Brassica oleracea

Colours: **purple, pink, red and blue/turquoise**
Parts used for dyeing: **the cabbage head**
Lightfastness: **good (4)**

Red cabbage is fun to experiment with because the colours vary greatly depending on the pH level of the bath. A pH neutral bath produces shades of purple, an acidic bath gives reddish purple, while an alkaline bath gives blue and turquoise shades. For greater lightfastness we experimented with the oven-baking method that Lisa Johansson used for beetroot in her book (see page 34).

Dyebath

About 200g (7oz) chopped red cabbage
3–5 litres (5¼–8¾ pints) water
100g (3½oz) mordanted yarn
100ml (3½fl oz) white vinegar (if you want to lower the pH) or 1tbsp bicarbonate of soda, ammonia or potash (if you want to raise the pH)
Rinse: white vinegar

It is fine to use red cabbage that has begun to wilt in the fridge. Oven-bake segments of the cabbage at 200°C (400°F) for about 1 hour. It does not matter if the outermost leaves become a bit burnt. Leave to cool a little and divide the cabbage into smaller pieces.

Place the pieces in a lidded bucket or a large glass jar with a lid. Add enough water to cover the cabbage plus a little more.

> Red shades: neutral bath, add nothing.
>
> Purple shades: acidic bath, add white vinegar until you have a pH value of about 4.
>
> Blue/turquoise shades: alkaline bath, add bicarbonate of soda, ammonia or potash until you have a pH value of about 10.

Leave the cabbage to stand in the water for 3–4 days in a warm place.
Strain off the cabbage. It will smell unpleasant.
Add the damp, mordanted yarn. Leave to stand for 3–4 days.
Rinse the yarn with a dash of white vinegar in the last rinse for neutral and acidic baths. Do not rinse the yarn from the alkaline bath in white vinegar.

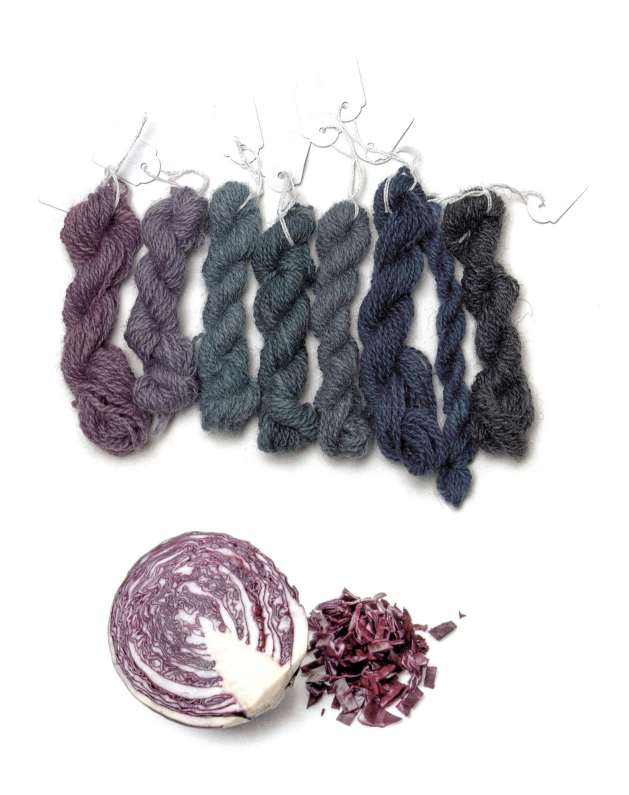

Walnut

Juglans regia

Colours: **brown (husks) and yellow and golden yellow shades (leaves)**
Parts used for dyeing: **the green husks surrounding the nuts, and the leaves**
Lightfastness: **excellent (5)**

The leaves and husks of the walnut tree have been used to dye textiles for centuries.

The leaves, stems and husks contain the brown colourant juglone, which is so potent that the yarn does not need to be mordanted.

The walnut tree is native to regions from South-east Europe to South-west China. It has become naturalized in lowland Britain and is related to the American black walnut, *Juglans nigra*, which can also be used for dyeing and produces similar colours. When we mention walnut husks, they are not the shells that hold the nuts when you buy them, but the green covering that surrounds the nuts when they grow on the tree.

If you do not have access to walnut trees, you can buy both the dried husks and the leaves.

Walnut husks produce brown colours, while the leaves give shades of yellow and yellow-green.

Walnut husk dyebath

100g (3½oz) walnut husks
3–5 litres (5¼–8¾ pints) water
100g (3½oz) mordanted or unmordanted yarn
Rinse: white vinegar

Soak the dried, crushed walnut husks for at least 48 hours.

Simmer them in water for 1 hour and strain off the husks. These can be saved for new dyebaths.

Leave the bath to cool, then add the damp yarn. Slowly raise the temperature to 85°C (185°F) and maintain this temperature for 1 hour.

Leave the yarn to cool in the bath.

Add a dash of white vinegar in the last rinse.

> An afterbath with added iron (ferrous) sulphate or iron water gives even deeper brown colours.

Walnut leaf dyebath

100g (3½oz) walnut leaves
3–5 litres (5¼–8¾ pints) water
100g (3½oz) mordanted or unmordanted yarn
Rinse: white vinegar

Soak the walnut leaves for at least 24 hours.
 Simmer the leaves in water for 1 hour and strain them off. The leaves can be saved for new dyebaths.
 Add the damp yarn and slowly raise the temperature to 85°C (185°F) for 1 hour.
 Leave the yarn to cool in the bath.
 Add a dash of white vinegar in the last rinse.

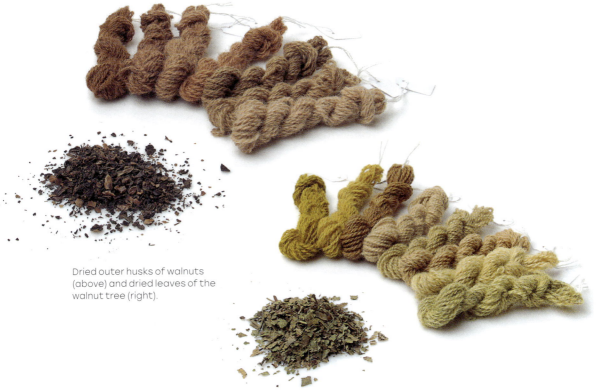

Dried outer husks of walnuts (above) and dried leaves of the walnut tree (right).

Indigo

Colour: **blue**
Parts used for dyeing: **dried pigment from dye plants**
Lightfastness: **exceptional (6)**

Indigo is not, as you might think, a specific plant, but a pigment found in over 200 plants around the world. Different plants contain different amounts of pigment. The most sought-after is the Indian species, *Indigofera tinctoria*, because it contains a lot of pigment.

Woad, *Isatis tinctoria*, which is both cultivated and found in the wild in Europe and some parts of the USA, contains the indigo pigment but in a lower concentration.

The name indigo was first recorded in English in 1289 and is derived from the Latin *indicum*, meaning Indian. Dyeing with indigo is one of the very oldest methods of botanical dyeing – it is more than 6,000 years old.

Synthetic indigo pigment has also been available since the mid-19th century. Natural and synthetic pigments are used in the same way, but synthetic indigo is considerably more potent and gives more baths.

Indigo pigment is not water-soluble, so the dyebath has to be prepared in a slightly different way, using a technique known as vat dyeing (see page 27).

The principle of vat dyeing with indigo is that you reduce the indigo to a yellow, water-soluble ion that will adhere to the yarn. This is done by using a reducing agent in an alkaline bath. In the old days people often used fermented urine, but there are many different methods. When you remove the yarn from the dyebath the reduced indigo reacts with the oxygen in the air and reverts to an insoluble blue pigment that adheres to the fibres. Indigo is also the most lightfast pigment there is.

A number of dye recipes with indigo use strong chemicals, such as caustic soda and sodium hydrosulphite. We have chosen to use a less toxic method.

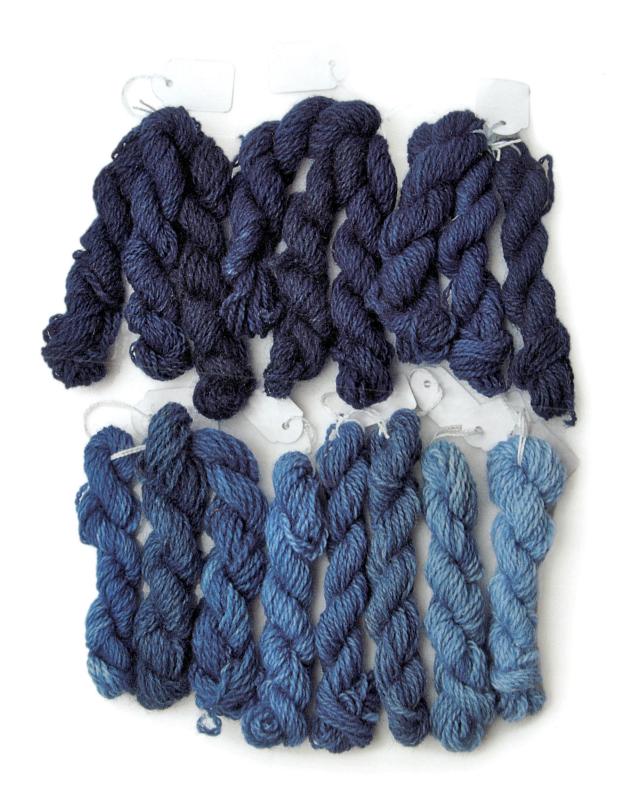

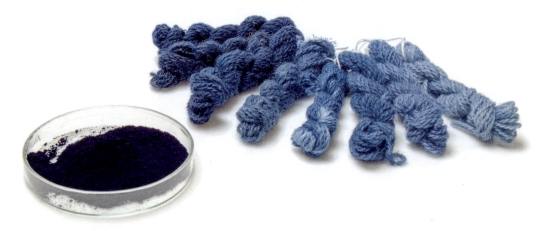

By dipping the yarn into the indigo bath several times, and allowing it to oxidize between dips, you can build up deeper and darker shades.

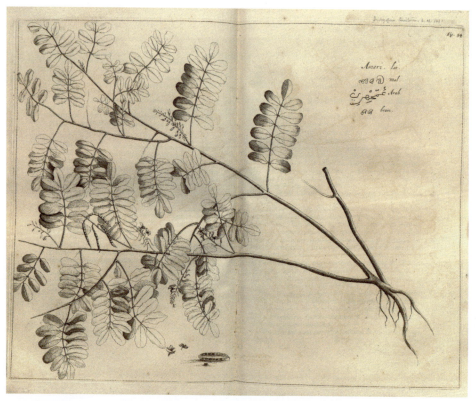

The indigo plant, from *Hortus Indicus Malabaricus*, a book dated 1678.

1-2-3 method

The very simplest indigo recipe, known as the 1-2-3 method, uses slaked lime and fructose for acid reduction. Remember to wear gloves, a mask and goggles when handling slaked lime.

Vat dye

5 litres (8¾ pints) water
30g (1oz) indigo powder (1 part)
60g (2oz) slaked lime (2 parts)
90g (3oz) fructose or glucose (3 parts)

Glucose (dextrose) can be bought in powder form in grocery stores, but you can also experiment by using overripe fruits, such as bananas, oranges, plums, nectarines or whatever you happen to have at home.

Make a paste using the indigo pigment and a little water.

Bring 5 litres (8¾ pints) of water to the boil and remove the pan from the heat. Add the slaked lime, then the glucose or fructose and lastly the 'wetted' indigo pigment. Stir well. Cover the pan and keep the bath warm by wrapping towels around the pan.

Leave to stand for 10 minutes. When the bath is ready, there will be a coppery film on the surface and the liquid underneath will be yellowish; this means that the bath has been reduced and is ready to use.

Dyeing with indigo

When dyeing with indigo it is sensible to wear gloves and hardwearing clothes and work in a safe, well-ventilated area.

Scrape the coppery film on the surface, known as the 'flower', to one side. Soak the yarn in water and squeeze out the excess.

Carefully lower the damp yarn into the dyebath and keep it submerged for 2–3 minutes. Then pull the yarn to the side of the pan and lift it carefully out of the bath, squeezing the liquid out against the edge of the pan. Note that it is important not to splash or introduce oxygen into the bath, as the dye will become weaker more quickly.

When you take the yarn out of the bath it will look yellow-green. It needs to be oxidized, meaning that the air must get to it, in order for the blue colour to emerge. Oxidize the yarn by shaking it gently; it can take up to 15 minutes to finish oxidizing.

Unlike what happens when you dye with plants, lichens and fungi, you can get deeper colours with indigo by dipping the yarn in the bath several times. The colour gets deeper with every dip and oxidation. You can repeat this process up to ten times.

When you see that the bath is no longer producing dye (the bath no longer looks yellow below the surface) you can add a little more lime and fructose or glucose (about half the amount listed in the recipe) and heat the bath to 50°C (122°F). Wait 10 minutes and try dyeing again. There is often more indigo pigment left in the bath to dye with. It is best to finish using the dyebath within a couple of days.

Rinse the yarn until the water runs clear.

The sugar in this recipe may make the yarn a little rough, so give it a bit of extra care with a dose of ordinary hair conditioner after washing, or wash in a wool-wash product containing lanolin.

Be aware that with indigo-dyed yarn, the colour may transfer.

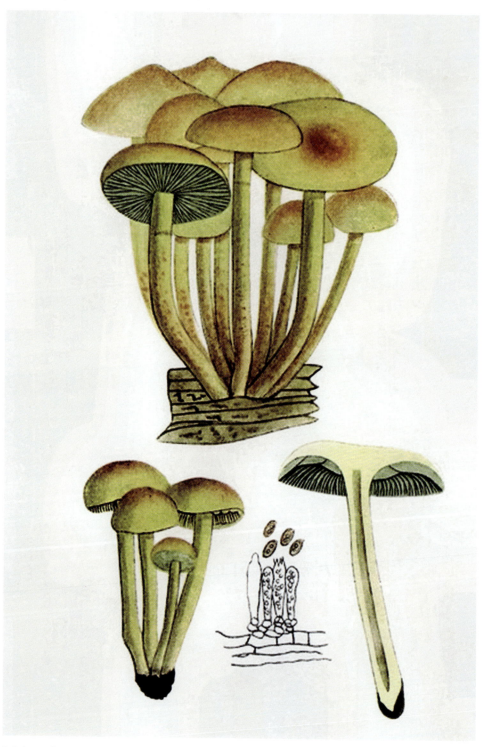

Sulphur tuft.

Dyeing with fungi

Dyeing with fungi was rediscovered and developed during the 1970s by the American artist Miriam C. Rice, but fungi are mentioned in dyers' handbooks from as far back as the 18th century.

A number of fungi are good to use as dye materials. In this book, we have chosen to include a few species that are easy to recognize and relatively common.

As most dyeing fungi are not edible – and some are even poisonous – it is important not to mix them with edible mushrooms in the same basket when you are out foraging.

Fungi are made up of a fruiting body (above ground) and mycelium, a netlike underground root system. Picking the fruiting bodies does not disturb the mycelium, but you could decide to leave one or two mushrooms to produce spores and possibly more mycelium. Follow the Countryside Code and respect nature and property owners.

When dyeing with fungi you can use unmordanted yarn, but mordanting with alum and cream of tartar gives the brightest colours.

It is fine to use fresh fungi for dyeing, but experience has convinced us that you get stronger, more concentrated dyes from dried fungi.

If you are not sure whether a fungus is one that can be used for dyeing, you can do the following micro test: place chopped pieces of the fungus and an odd end of yarn (preferably mordanted yarn) in a bowl with a little water and pop it in the microwave for about 30 seconds. If the yarn has absorbed colour, it may be worth investigating the fungus more closely.

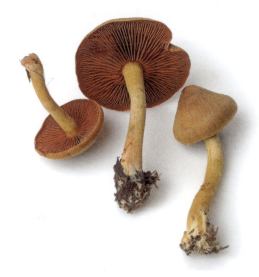

The surprise webcap mushroom has a brown cap, dark red gills and a pale yellow stalk.

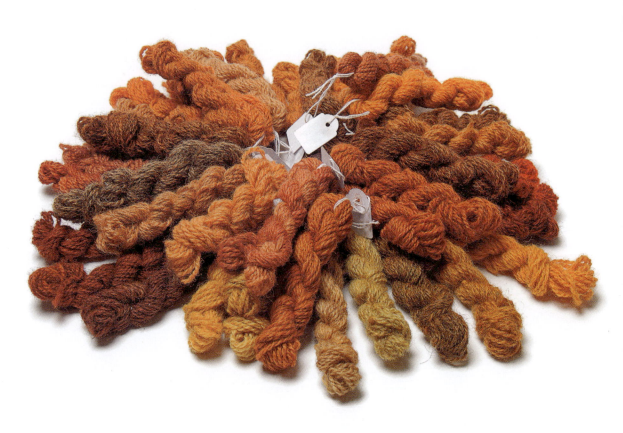

Surprise webcap mushroom

Cortinarius semisanguineus

Colours: **red, red-orange, orange**
Parts used for dyeing: **cap and stalk**
Lightfastness: **excellent (5)**

A number of mushrooms in the *Cortinarius* family can be used for dyeing. They produce red, orange, yellow, brown or green colours, but it can be difficult to tell them apart and determine which one you have found.

We have chosen to include the surprise webcap mushroom because it is easy to distinguish and common in spruce plantations in the UK.

It is a small mushroom, about 5–7cm (2–2¾in) with a fully developed cap, and can be recognized by the dark red gills on the underside of the cap and its pale yellow stalk. The bottom of the stalk is often red.

It grows in coniferous woodland, often surrounded by lichens and rocks and often in clusters, so if you have found one, look around and you will usually find more. The growing season lasts from September to November.

The surprise webcap contains anthraquinone dyes that are very lightfast.

This fungus produces a lot of dye and can be used for many afterbaths. It is fine to dye with the whole mushroom, but the colourants in the caps are more red, while the stalks tend towards orange.

It can be a good idea to collect fungi during the season. If you dry them, it is best to split the caps from the stalks and store the parts separately.

Dyebath

40g (1½oz) dried or about 120g (4¼oz) fresh surprise webcap mushrooms
3–5 litres (5¼–8¾ pints) water
100g (3½oz) mordanted or unmordanted yarn

Boil the dried mushrooms for 1 hour and leave to stand overnight. Do not strain off the mushrooms; leave them in the dyebath.

Add the damp yarn to the bath, heat to 85°C (185°F) and maintain this temperature for 1 hour.

Allow the yarn to cool in the bath.

Take the yarn out and rinse it.

You can then add new yarn and raise the temperature to 85°C (185°F) for 1 hour.

We have tested up to five afterbaths, all of which produced dye.

Velvet roll rim mushroom

Tapinella atrotomentosa

Colours: **brown, dark purple, green and grey-blue**
Parts used for dyeing: **the entire mushroom**
Lightfastness: **excellent (5)**

The velvet roll rim mushroom is a large fungus with a cap that grows up to 20cm (7¾in) across. When you are out walking you can quickly collect enough for a dyebath. More common in Scotland than in the rest of the United Kingdom, it grows in older coniferous forests and thrives best on tree stumps and rotting roots. It is easily distinguishable from other roll rims as it has a brownish-black, velvety stalk. It is an exceptionally good fungus for dyeing that produces a lot of dye, deep shades and can be used for many afterbaths.

This mushroom contains a lot of water and easily rots if it is not dried.

You can obtain many colours from this fungus, from brown to olive green, grey-blue and purple, depending on pH value and time.

Dyebath

200g (7oz) dried velvet roll rims
3–5 litres (5¼–8¾ pints) water
100g (3½oz) mordanted or unmordanted yarn
1tsp ammonia, potash or bicarbonate of soda
 (if you want a higher pH value)
Rinse: white vinegar

Simmer the mushrooms for 1 hour.

We recommend leaving the mushrooms in the dyebath when dyeing.

The colours will be brightest if you use yarn mordanted with alum and cream of tartar. Unmordanted yarns give paler colours. Heat the bath to 85°C (185°F) and maintain this heat for 1 hour. Leave the yarn to cool in the bath.

Rinse the yarn with a dash of white vinegar in the last rinse (unless you have raised the pH level).

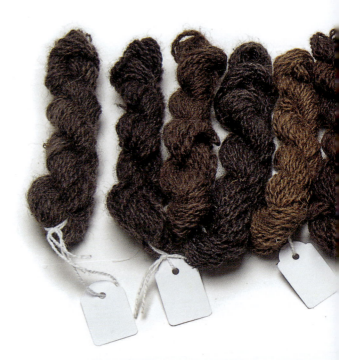

For shades of purple: heat the mushrooms and yarn together to 85°C (185°F). In this case it is important to remove the yarn as soon as you see it beginning to turn purple, usually after just 30 minutes.

For shades of brown: use the pH value of the mushrooms.

For shades of grey-blue and olive green: raise the pH by adding 1tsp of ammonia, potash or bicarbonate of soda to the dyebath.

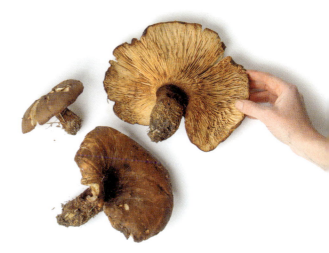

Older specimens of velvet roll rim mushrooms. They contain a greater variety of colourants: atromentin, flavomentins and spiromentins.

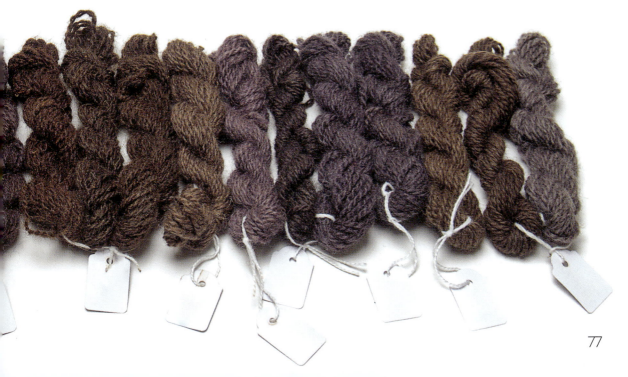

Scaly tooth fungus

Sarcodon squamosus

Colours: **blue, brown, blue-grey, green-grey**
Parts used for dyeing: **the entire fungus**
Lightfastness: **good (4)**

Scaly tooth fungus is large and brownish-grey, with a cap up to 20cm (7¾in) across, covered with concentric circles of large scales and is again more common in Scotland than the rest of the UK. The underside of the cap is covered with white or buff spines and the stem has a uniform thickness. It grows in pine forests in smallish groups or rings. The older the fungus is, the darker it becomes.

Scaly tooth fungus resembles the fungus known as shingled or scaly hedgehog, *Sarcodon imbricatus*, which can also be used for dyeing, but gives light beige colours and grows in spruce woods rather than pine forests.

Scaly tooth fungus contains thelephoric acid, which produces shades of blue, and also the brown colourant atromentin. This means you can get blue and brown colours from the same fungus.

We recommend picking overripe fungi, preferably blackish and slimy, or allowing the fungi to rot outdoors in a bucket with a lid for a couple of weeks in order to get the blue shades to come out as much as possible. Note that dried scaly tooth fungus does not give the same deep colours and you will need a considerably larger quantity if you have dried it.

Dyebath

500g (17½oz) dried, or 3-4 large, rotted scaly tooth fungi
3-5 litres (5¼-8¾ pints) water
100g (3½oz) mordanted yarn (we recommend mordanting with alum and cream of tartar)
1tsp ammonia, bicarbonate of soda or potash

Boil the fungi vigorously, preferably for 3–4 hours.

To get the desirable blue colours you first need to draw as much as possible of the brown dye (atromentin) out of the dyebath. To do this, leave the yarn in the dyebath overnight; this wil make the yarn turn brown.

Increase the pH of the bath to 8–10 by adding ammonia, bicarbonate of soda or potash. After that, you can continue dyeing as usual, that is, for 1 hour at 85–90°C (185–194°F), and then the colours will be blue-grey.

You can usually get 2–3 dyebaths from one batch of boiled fungi. Check the pH and adjust it if necessary with each dye session.

We have noticed that it is important to add oxygen to the bath during dyeing: stir frequently and move the yarn in and out of the bath a few times during dyeing. The yarn will look brown when you take it out of the bath, but do not despair; the brown colour will disappear when you wash and rinse the yarn.

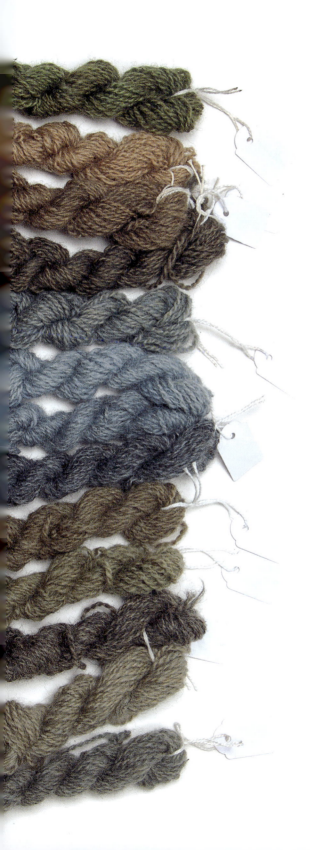

Yarn mordanted with rhubarb produces shades of green.

Afterbath with iron water produces blue-green shades.

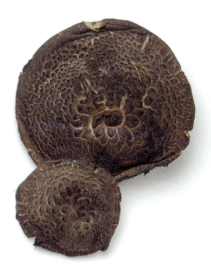

Scaly tooth fungus is one of a family of tooth fungi; the underside of the cap is covered with pale, densely packed beige spines.

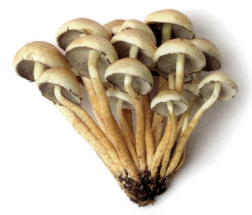

Sulphur tuft often grows in dense clumps. The entire fungus is yellow, almost sulphur yellow, but when it gets old, the gills turn a darker, green-grey colour.

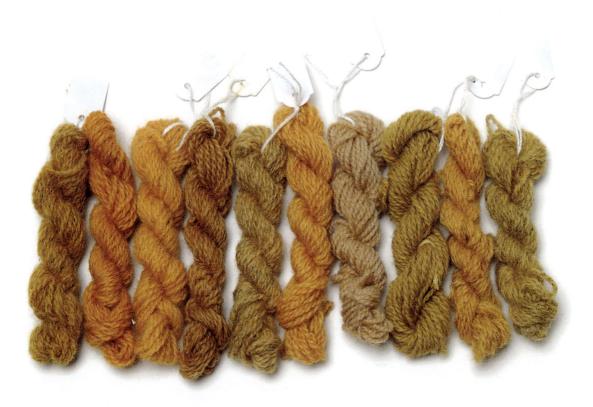

Sulphur tuft

Hypholoma fasciculare

Colour: **yellow**
Parts used for dyeing: **the whole fungus**
Lightfastness: **good (4)**

Sulphur tuft is a woodland fungus that grows in large clumps on the stumps or dead roots of deciduous trees. It is common in the United Kingdom and North America and can be picked from spring to autumn, when there is no frost. It is sulphur yellow and has a faint musty smell.

Because this fungus is so common, it is usually easy to collect a lot of it on a single walk. It contains the colourant hypholomin which produces shades of yellow.

Note! This fungus is poisonous if eaten.

Dyebath

500g (17½oz) dried or about 1.5kg (3¼lb) fresh sulphur tuft
3–5 litres (5¼–8¾ pints) water
100g (3½oz) mordanted yarn – pH 7. Yarn mordanted with alum and cream of tartar is recommended
1tsp ammonia, potash or bicarbonate of soda (if you want a higher pH value)
Rinse: white vinegar

Boil up the fungi and simmer for 1 hour. Strain off the fungi and leave the dyebath to cool.

Add the damp, mordanted yarn, bring the temperature up to 85–90°C (185–194°F) and maintain this temperature for 1 hour.

Preferably leave the yarn to cool in the bath.

Rinse the yarn with a dash of white vinegar in the last rinse (unless you have raised the pH level).

> For a brighter yellow, add 1tsp ammonia, potash or bicarbonate of soda during the last 10 minutes of dyeing.

Rock tripe.

Dyeing with lichens

Some people we have spoken to believe that all lichens are protected species, but this is not so. However, lichens grow very slowly, so you should collect only those that are loosely attached or have fallen to the ground from rocks or trees. We collect fallen lichens when out for a walk after it has rained.

Lichens have been used for dyeing textiles for thousands of years. Archaeologists have found Bronze Age textiles that bear traces of lichen dye. For a long time dyeing with lichens was an inexpensive and easy alternative to the murex snails from which the sought-after, costly Tyrian purple dye was extracted.

The dye from some lichens, such as crottle, can be extracted by boiling it in water in the same way as for most plants. Other lichens, such as rock tripe, contain vat dye substances and have non-water-soluble pigments that require fermentation in order to extract the dye.

The purple colourant was often fermented in urine to produce a vat dye. Nowadays we can use ammonia mixed with water in a tightly closed jar left to stand on a sunny windowsill.

You need to be patient when fermenting lichen dyes, as the process requires the dyebath to be prepared months in advance. In addition, it is best if you give the bath a good shake every day to oxidize it and occasionally let some air into the jar. It is a good idea to have a number of jars on the go at the same time, because the process is finicky – some dyebaths may take a few weeks and others several months to turn into the desired colour.

Many lichens produce dyes, but not all. If you are not sure about the species, there are a couple of simple tests you can do to see if you have found one you can dye with.

K-test: scrape the surface of the lichen with a knife to get to the white 'marrow'. Take a cotton bud with a little caustic soda on it and poke the lichen. If the cotton tip turns yellow, red or purple, the lichen can be used for dyeing using the boiling method.

C-test: do the same as above, but using bleach instead. If there is a colour reaction you can dye with the lichen using the fermentation method.

When dyeing with lichens, the yarn does not need to be mordanted, but different mordants may produce different shades.

Rock tripe

Lasallia pustulata

Colours: **reddish-purple**
Parts used for dyeing: **the entire lichen, dried and crumbled**
Method: **fermentation method**
Lightfastness: **good (4)**

For anyone with patience this is worth the effort!

Rock tripe grows on rocks and boulders in many parts of the world. It thrives best on surfaces that are fertilized by bird droppings, often near lakes and watercourses. It is brownish to black in colour, with blister-like structures on its upper surface, and looks a little like burnt breakfast cereal. It is anchored to the rock at a single point and can grow up to 20cm (7¾in) in diameter.

In the past, rock tripe was used to make ink as well as for botanical dyeing, as it produces a desirable, reddish purple colour.

The colour appears through fermentation; in former times it was fermented with urine, but we prefer to use household ammonia.

Vat dye

250ml (8¾fl oz) dried, crumbled rock tripe
250ml (8¾fl oz) water
250ml (8¾fl oz) ammonia (24.5%)

Dry the rock tripe, crush it in a mortar and place it in a fairly large glass jar with a lid. Cover with equal parts of water and household ammonia (24.5%). Fill the jar only half way. Then give it a good shake and stand it by a sunny window.

The time it takes for the vat dye to be ready varies, but reckon on 6–9 months.

To begin with, give the jar a good shake several times a day for a week and after that once a day. A couple of times a week take the jar outdoors and open it up for a few minutes to introduce oxygen.

The vat dye is ready when the liquid in the jar turns a purplish colour. If it is still wine-red after about 9 months, do not lose heart – try whisking it and introducing oxygen while heating it.

Dyebath

Because of the strong fumes from the ammonia, this type of dyeing is best done outdoors.

Strain off the rock tripe and save it, as it can be used again for a new vat dye.

250ml (8¾fl oz) vat dye
3 litres (5¼ pints) water
125g (4½oz) table salt (NaCl)
50g (1¾oz) mordanted or unmordanted yarn

Pour the water into a pan, dissolve the salt and add the vat dye.

It's worth noting that a stronger concentration of vat dye in relation to water gives darker colours, so you can experiment with this.

Measure the pH, add more ammonia if necessary to obtain a pH of 9–10. Give the dyebath a good stir to introduce oxygen; the bath may then turn from wine-red to a more purple shade.

Add the damp yarn, bring the temperature up to 85–90°C (185–194°F) and maintain this temperature for 1 hour.

The yarn may be left in the dyebath overnight.

If you want to dye several times in the bath, check the pH again and add more ammonia if required.

To give greater colour fastness, let the dyed yarn dry thoroughly for a couple of days before washing it in cold water.

Do not use white vinegar in the last rinse.

Dried rock tripe should be stored in a dry place, for example in a jar with a tightly fitting lid.

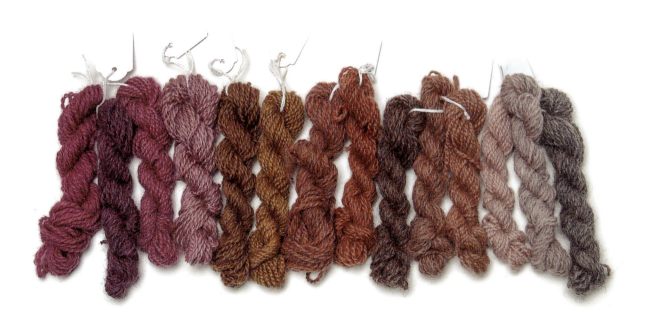

Crottle

Parmelia saxatalis

Colours: **brown, orange and yellow-orange**
Parts used for dyeing: **the whole lichen**
Method: **boiling method**
Lightfastness: **excellent (5)**

For those who are impatient and want to dye straight away! Crottle can be boiled and used for dyeing directly.

Crottle is commonly found in Scotland. It grows on stones and flat rocks, usually in round grey or green rosettes, and has been used for dyeing textiles since the days of the Vikings. It produces shades of brown, orange and yellow – although it has also been said that 30 different colours can be produced from this lichen.

Remember to collect only lichen that has come loose from the rock, for example after heavy rain.

Dyebath

200g (7oz) dried, crushed crottle
3–5 litres (5¼–8¾ pints) water
100g (3½oz) mordanted yarn

Add the crottle to the water and heat the bath to 85°C (185°F). Maintain this temperature for a couple of hours. Allow the bath to cool and add the damp yarn.

To get the deepest colours you can leave the crottle in the dyebath. To prevent the yarn from becoming full of lichen crumbs and difficult to clean, you can put it in the bath in a laundry bag.

Heat the bath to 85°C (185°F) again and maintain this temperature for 1 hour.

It is a good idea to let the yarn cool in the bath and remain there overnight, then heat it up again to 85°C (185°F) for another hour the next day.

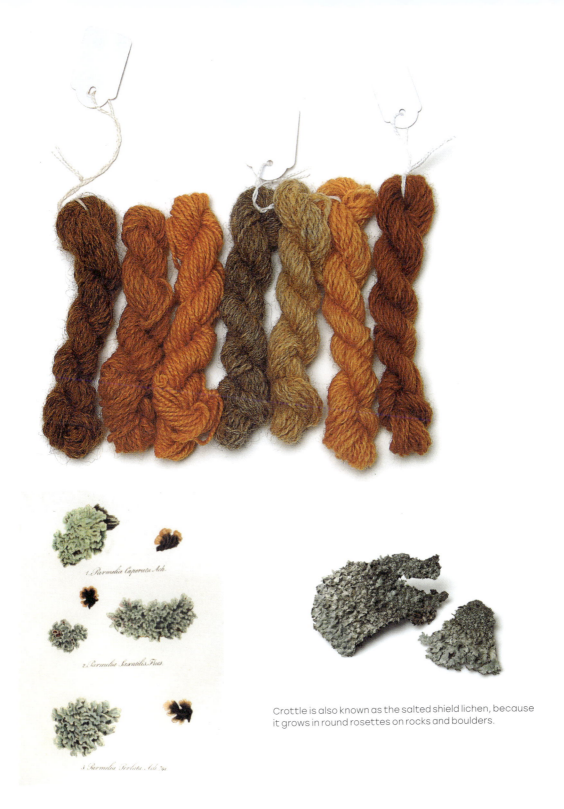

Crottle is also known as the salted shield lichen, because it grows in round rosettes on rocks and boulders.

Next steps

Using the same dyebath more than once and overdyeing

In most cases there is dye left in the bath after the first dyeing. This means you can dye several batches in the same bath, enabling you to use up all the dye and get further subtle variations of colour. The number of batches one bath can give you depends on the concentration of the bath and the colourant; some colourants go a very long way, while others do not. However, later baths tend to be somewhat less lightfast than the first one.

Experimenting with overdyeing – dyeing with different weak baths one on top of the other – can produce subtle and unexpectedly attractive effects, for example, dyeing with indigo over a yellow-dyed yarn will produce shades of green. Do not forget the pale shades; you will need those too when you knit patterns in multiple colours.

Afterbaths

You can include an afterbath near or after the end of the dyeing process. They can be used to increase lightfastness and to extract further subtle shades.

An afterbath with potash makes red colours more red, an afterbath with citric acid makes the colours warmer, and one with ammonia makes yellow colours brighter and reds turn towards purple. An afterbath with copper or iron makes the colours darker and improves lightfastness.

The recipe will tell you which afterbath is suitable for the dye concerned.

Afterbath with copper or iron

8g (¼oz) copper sulphate or iron (ferrous) sulphate dissolved in 100ml (3½fl oz) water or 100ml (3½fl oz) copper water or iron water (see recipe on page 22)

Allow the dyebath to cool a little, remove the yarn from the pan and put it in a bucket for the time being. Stir the copper or iron solution into the dyebath, give it a good stir and return the yarn to the bath.

Heat the bath to 85°C (185°F) and maintain this temperature for about 15 minutes.

Never use more than 8% copper sulphate or iron (ferrous) sulphate in proportion to the dry weight of the yarn in an afterbath. Too long a time and too strong a concentration will make the yarn rough and friable.

Care

Leave the yarn to cool in the bath, preferably overnight. Hang up the yarn and leave it to dry. After that it can be rinsed in lukewarm water. In most cases add a dash of white vinegar in the last rinse. Note that yarn dyed in alkaline baths should not be rinsed with white vinegar.

After a couple of weeks when the dye has 'settled in' you can wash the yarn with a few drops of shampoo. This particularly applies to dyes that have a tendency to rub off, such as indigo and logwood. If the yarn feels rough and stiff, you can give it a wash with ordinary hair conditioner or wool shampoo containing lanolin.

Do not lose heart if the colour turns out to be one you do not like. Give it another chance by overdyeing the yarn in a different bath. Experimenting with overdyeing is exciting and can produce surprisingly good results.

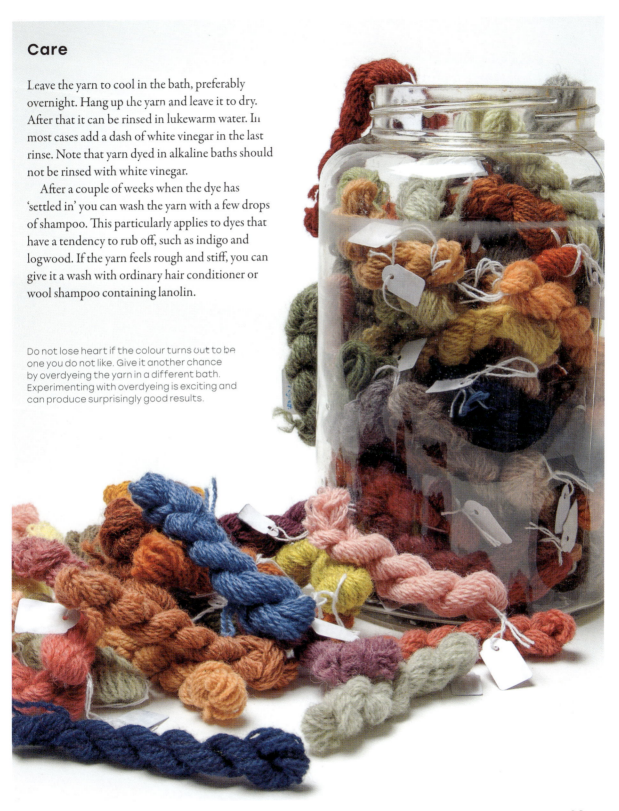

Glossary

Alum

Potassium aluminium sulphate, $KAl(SO_4)_2 \cdot 12H_2O$. Alum is a salt in the form of white crystals or powder obtained from bauxite. Alum is the most common mordant and is used to make the dye adhere better and improve light- and colourfastness. It does not affect the yarn or the colour of the dye. As a rule, other mordants are used together with alum. It can be used on both protein and cellulose fibres.

Ammonia

NH_3. Ammonia is a colourless liquid with a very strong smell. Ammonia is strongly alkaline and is used in botanical dyeing to raise the pH value. It vaporizes easily, so keep the lid on. In this book we are always referring to a concentration of 24.5%, known as household ammonia, which can be purchased from paint stores.

Citric acid

$HOC(CO_2H)(CH_2CO_2H)_2$. As its name suggests, citric acid is found naturally in lemons and certain other fruits and vegetables (and is also produced in human and animal tissues). It is also produced chemically by fermenting sugar solutions. Citric acid is used as a preservative in foodstuffs and as an acidity regulator. It consists of colourless crystals (white powder).

It can be purchased from supermarkets and food stores.

Copper sulphate

$CuSO_4$. This is a salt consisting of blue crystals, soluble in water. Can be purchased from paint stores or hardware stores. Used as a mordant together with alum to make the colours darker and increase colourfastness.

Remember that copper sulphate is poisonous, so wear gloves and a mask.

If you want to make it easier to handle when dyeing, you can dilute the crystals in a little hot water and keep the solution in a glass jar with a tight-fitting lid, so that you have the solution ready to add to the dyebath. Instead of using copper sulphate you can experiment with copper water or dye in a copper pan.

Cream of tartar

Potassium bitartrate, $KC_4H_5O_6$. Cream of tartar comprises natural salt crystals that form as deposits on the inside of wine barrels. Used as a mordant together with alum to get brighter shades from most colourants. The exception is logwood, which turns brown on yarn mordanted with cream of tartar.

Iron (ferrous) sulphate

$FeSO_4$. Iron sulphate is a salt consisting of blue-green crystals. Can be purchased from paint stores or hardware stores. Used as an afterbath for yarn, partly to modify the colour and partly to increase the dye's permanence. Makes colours darker and more subdued, in some cases almost black. Use with care, as it may make the yarn brittle. Instead of using iron (ferrous) sulphate you can experiment with rust water or dye in an iron pan. Remember that iron (ferrous) sulphate is poisonous, so wear gloves and a mask.

Potash

Potassium carbonate, K_2CO_3, is a white salt that gives an alkaline solution when mixed with water. Potash was formerly an important raw material in the production of glass, soap, medicines and in botanical dyeing. It was produced by leaching ash from deciduous trees and boiling the lye, which was evaporated in clay pots – hence the name potash.

Tip

You can try making your own potash. When you have had a wood fire, collect the white ash. Remove any sticks and pieces that have not burned away completely. Take 300–400ml (10½–14fl oz) of ash to 1 litre (2 pints) of water and simmer for 1 hour. Leave to stand overnight until the ash has sunk to the bottom of the pan. Pour off the water through a plastic coffee filter or a towel. Leave the ash to dry, and you have potash.

Slaked lime

Calcium hydroxide, $Ca(OH)_2$, or slaked lime, is a chemical compound of calcium oxide and water. It is produced by mixing burnt lime with water. Slaked lime is strongly alkaline and corrosive. It can be purchased from garden centres.

Wear gloves and a mask when handling slaked lime.

References

Further reading

Buchanan, Rita, *A Weaver's Garden*, Loveland, Colorado: Dover Publications, 1987

Casselman, Karen Leigh, *Craft of the Dyer: colour from plants and lichens*, Toronto: University of Toronto Press, 1980

Coles, David, *Chromatopia – An illustrated History of Color*, New York: Thames & Hudson, 2018

Dean, Jenny, *Wild Color – The Complete Guide to Making and Using Natural Dyes*. New York: Watson-Guptill Publications, 1999

Diadick Casselman, Karen, *Lichen Dyes – The New Source Book*, Cheverie, Nova Scotia: Studio Vista Publications, 1996

Liles, James N., *The Art and Craft of Natural Dyeing: traditional recipes for modern use*, Knoxville: The University of Tennessee Press, 1990

McLaughlin, Chris, *A Garden to Dye For*, Pittsburgh, USA: St Lynn's Press, 2014

Bonus projects

Two knitting patterns, designed by the authors and created using hand-dyed yarn, are available to download free from the Bookmarked Hub: www.bookmarkedhub.com

Choose from a comfortable, stylish skirt knitted in yarn dyed with red and yellow onion, birch and dyer's weed; or a flattering, decorative capped-sleeve top, using yarns dyed with indigo and brazilwood among other things.

Search for this book by title or ISBN: the files can be found under 'Book Extras'. Membership of the Bookmarked online community is free.

List of illustrations

These credits are listed by page.

28 Madder stem and root (*Rubia tinctorum*) from L. Figuier, *Les merveilles de l'industrie* (1873), CC PDM 1.0.

33 Madder. *Rubia tinctorum* from M.A. Burnett & G.T. Burnett, *Plantae utiliores* (1840–1850), CC PDM 1.0.

35 Beetroot (top right), school wall chart: Kitchen plants I

37 Plums (top right), from thegraphicsfairy.com

38 Yellow onion (centre right), from thegraphicsfairy.com

41 Birch (top right) from C.A.M. Lindman, *Nordens flora* (1901–1905)

43 Red onion (centre left), school wall chart

45 Tansy from C.A.M. Lindman, *Nordens flora* (1901–1905)

47 Golden Marguerite (bottom left) from C.A.M. Lindman, *Nordens flora* (1901–1905)

51 Rhubarb (top left), school wall chart: Kitchen plants III.

53 Heather from C.A.M. Lindman, *Nordens flora* (1901–1905)

55 Dyer's Weed (weld) (bottom left) from C.A.M. Lindman, *Nordens flora* (1901–1905)

57 Eucalyptus (bottom left) from P. Mouillefert, *Traité des arbres...* (1892–1898), CC BY 2.0.

62 Brazilwood (top left) from L. Byam, *A collection of exotics from the island of Antigua* (1797), CC BY-SA 4.0.

67 Walnut (top right) from F. A. Michaux, *The North American Sylva...* (1819), PD-US.

70 Indigo (bottom) from *Hortus Indicus Malabaricus* (1678), CC BY 4.0.

72 Sulphur tuft from G. Bresadola, *Iconographia Mycologica*, vol. XVII (1931), CC-PD

77 Velvet roll rim mushroom (top right) from E. Gramberg, *Pilze der Heimat* (1913), PD

80 Sulphur tuft (top right) from G. Bresadola, *I funghi mangerecci e velenosi dell'Europa media, con speciale riguardo a quelli che crescono nel Trentino* (1906), PD

82 Rock tripe from J. W. Palmstruch, *Svensk botanik* (1802–1819)

87 Salted shield lichen (in the middle of the plate, bottom left) from J. Kops, *Flora Batava*, vol. 10 (1849), PD

A guide to abbreviations

CC BY = Creative Commons with attribution
CC BY-SA = Creative Commons Share-Alike (with attribution)
CC PDM = Creative Commons, Public Domain Mark
PD = Public Domain

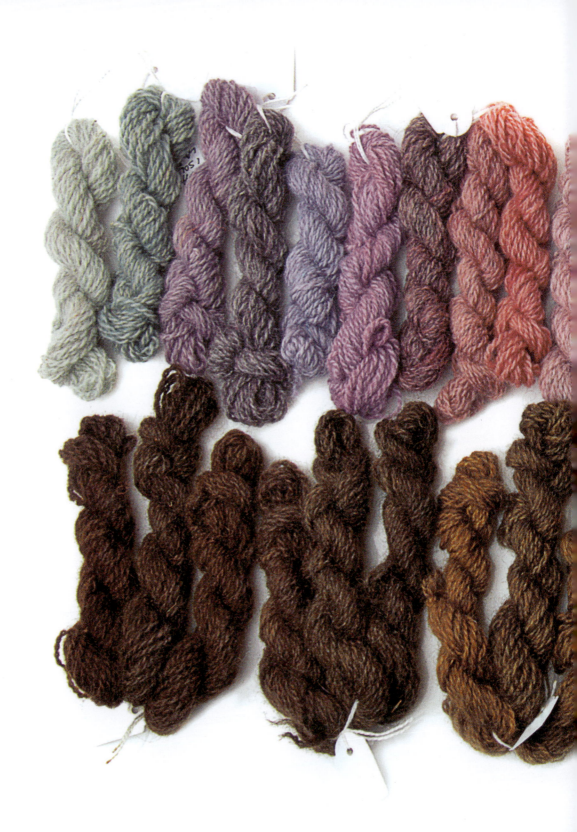

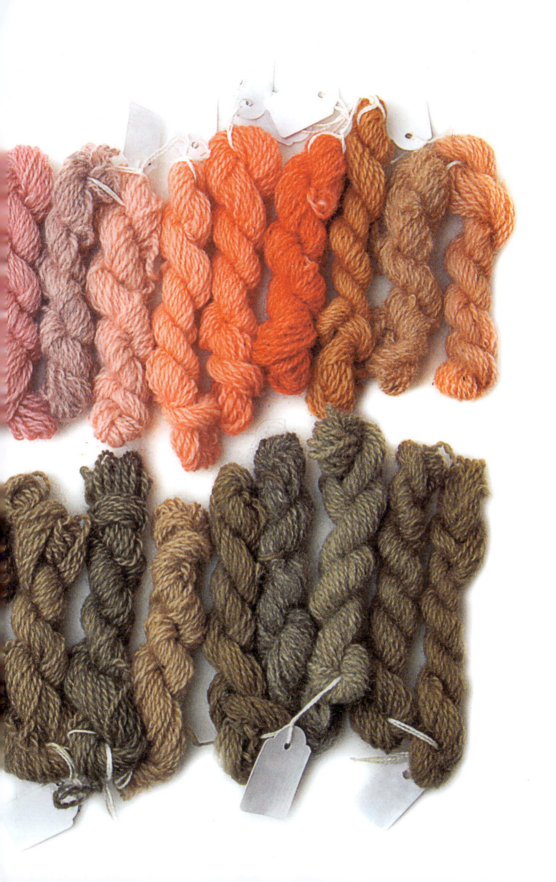

Our thanks to

Sophia Lundquist, our editor, for holding the reins and cheering us on
Annika Lyth for the graphic design
Per Lincoln, chemist and indigo enthusiast, for checking the facts
Dicte Helmersson, mushroom consultant, who checked the fungi
Lovisa Skog and Bingo Joviken of GarnR,
Petra Mikaelsson Hafredal of Fru Valborg,
Paula Lonnqvist of Knit4you and Maja Karlsson of Järbo for sponsoring the yarn

Last but not least:
Thanks to our families for their patience with us during the process and for putting up with everything from rotten mushrooms on the balcony and jars with suspicious contents to onion skins in the freezer and yarn – yarn everywhere.

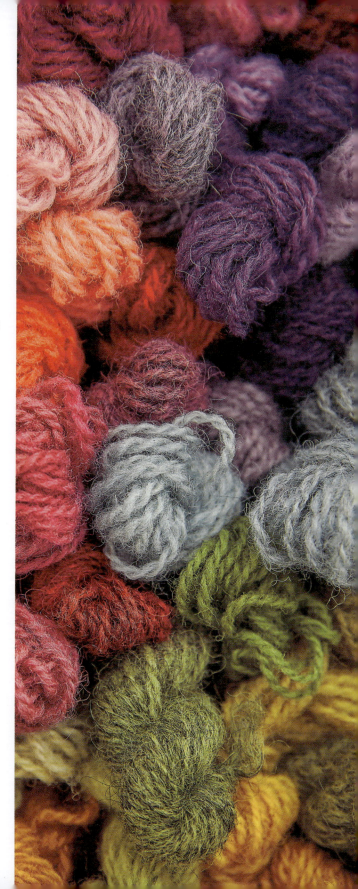